AFTER IKE

Number Seventeen: Gulf Coast Books
Sponsored by Texas A&M University–Corpus Christi
John W. Tunnell Jr., General Editor

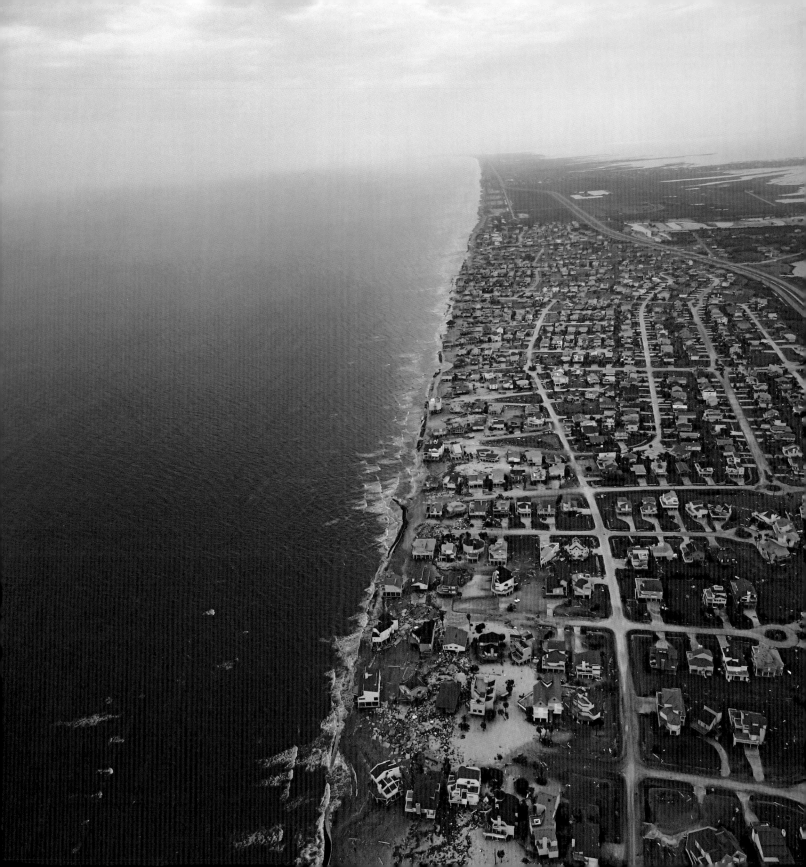

AFTER IKE

Aerial Views from the No-Fly Zone

BY BRYAN CARLILE

Living in Hurricane Alley, an essay by Andrew Sansom

Texas A&M University Press • College Station

This paper meets the requirements
of ANSI/NISO Z39.48-1992 (Permanence of Paper).
Binding materials have been chosen for durability.

LIBRARY OF CONGRESS CATALOGING-IN-PUBLICATION DATA

Carlile, Bryan.
 After Ike : aerial views from the no-fly zone / by Bryan Carlile ;
essay by Andrew Sansom. — 1st ed.
 p. cm. — (Gulf Coast books / sponsored by Texas A&M
University–Corpus Christi; no. 17)
 ISBN-13: 978-1-60344-150-6 (flexbound with flaps : alk. paper)
 ISBN-10: 1-60344-150-6 (flexbound with flaps : alk. paper)
 1. Hurricane Ike, 2008—Aerial photographs. 2. Hurricane Ike,
2008—Pictorial works. 3. Hurricanes—Texas—Gulf Coast—Aerial
photographs. 4. Hurricanes—Texas—Gulf Coast—Pictorial works.
5. Hurricane damage—Texas—Gulf Coast—Aerial photographs.
6. Hurricane damage—Texas—Gulf Coast—Pictorial works.
7. Gulf Coast (Tex.)—Aerial photographs. 8. Gulf Coast (Tex.)—Pictorial
works. 9. Gulf Coast (Tex.)—History.
I. Sansom, Andrew. II. Title. III. Series: Gulf Coast books ; no. 17.
F392.G9C37 2009
97.64'10640222—dc22
2009016343

With immense admiration
I dedicate this book
to my beloved Karen,
whose brilliance and love
have given flight to this book.
Thank you for teaching me
that unconditional love and friendship
can overcome any storm.
I pray I always return
from my adventures
to your loving embrace.

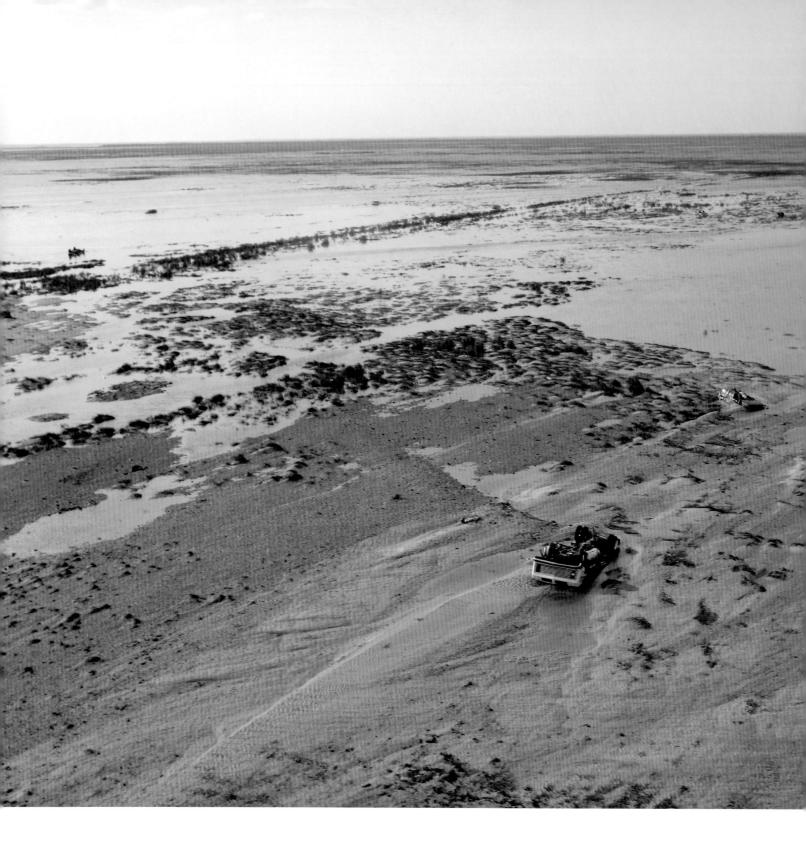

Contents

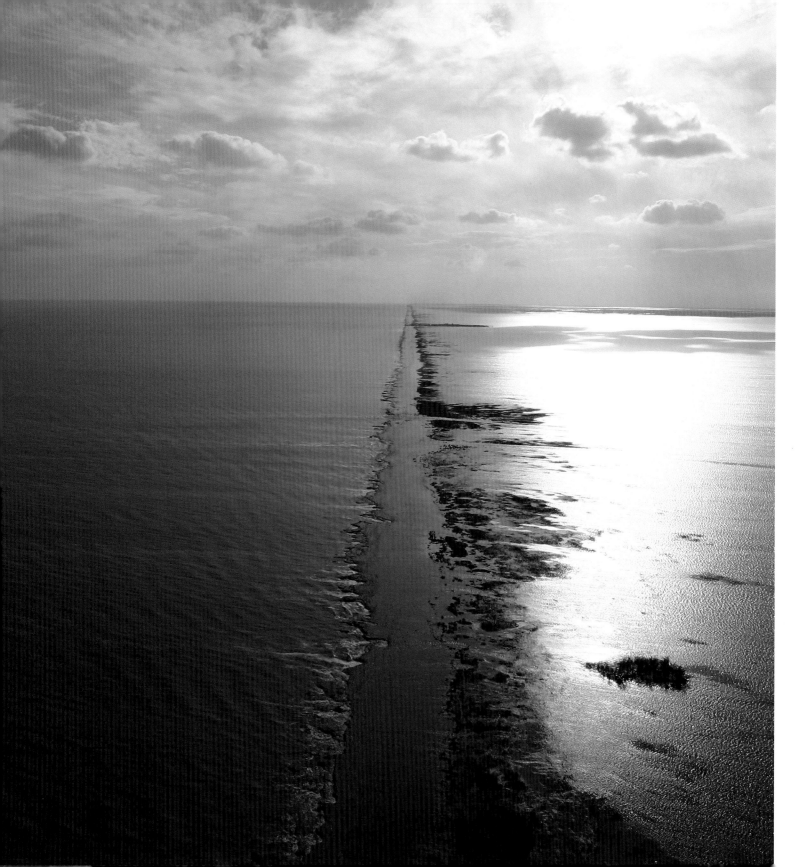

Preface

The Texas Gulf Coast feels like home to me. For many Texans, it is both a destination and a state of mind—a place for rest, recreation, and escape, offering solace and peace to all who seek them. Truly, it is a mecca to nature lovers, sportsmen, and tourists. I have spent countless hours flying above the grandeur of the coast, and I have worked in its marshes and prairies, sanctuaries and preserves. I have studied the coastal landscape for so many years that I can recall its contours by memory. I have soared in its skies, felt its sand between my toes, and held its wildlife in my hands. I've hiked, biked, skied, and fished along its beaches. This land offers me a sense of being and a place of belonging. To many of us, the Texas Gulf Coast is a touch point that somehow allows our minds to be free while keeping us grounded.

With a force I pray we never witness again, Hurricane Ike slammed into the Texas Gulf Coast on September 13, 2008. The days following landfall were challenging, stressful, depressing, and yet I felt exhilarated. The world around me was without power, communication, fuel; people were suddenly rendered homeless and hungry. For those with homes, many felt they could not leave, trapped by the idea of vandalism, theft, or further water and wind damage. Flooded streets prevented travel for others. It was in this frenetic, disorganized atmosphere that I found consolation in a cockpit, escaping the tragedies that had befallen my friends and family by documenting the wrath of Hurricane Ike.

In the days after the storm, a Temporary Flight Restriction was in effect, allowing official aircraft into the skies above the coast but restricting general civil aviation. Helicopters and planes from the military, government agencies such as FEMA, and oil and gas companies conducted search and rescue missions as well as surveillance and assessment flights.

Almost daily, I climbed into the air, eager to escape the chaos on the ground. Soon I would be surrounded by the familiar smell of aviation fuel permeating the cockpit, the comfortable feel of rotating blades slicing the air, and a sense of anticipated freedom. Each time I embarked, I felt adrenaline pump through my veins. Somewhere between being excited and terrified, I wondered what we would see from our safe perch in the air. At the end of each day I returned, quiet, humbled, and drained of

emotion. I felt numb from what I experienced and empty, like the landscape I documented, having spent my days in the eye of the other storm that followed Ike's assault. Back home, without electricity, I could not download my cameras' data cards, and found myself running to use my neighbor's generator as I switched out cameras and battery packs.

Toward the end of a week, the skies emptied and the coastline shifted in ever-increasing transformation as I watched the flood waters recede throughout the area. The storm surge that pushed through Bolivar Peninsula retreated, carrying with it wildlife, boats, and remnants of lives and livelihoods lost. On the final day I was able to shoot, I took videos of the coastline from south Galveston Island to High Island on Bolivar Peninsula. The landscape was fresh with change and the atmosphere clearer than I had ever seen it.

I have found that aerial photography affords a generous view of what lies below. While large-scale harm to the landscape and environment may be visible from above, human struggle is rendered invisible at such a distance. The aerial lens misses the details of hardships and avoids both civil and political unrest. In a way, it allows for the better side of humankind, portraying what we created beforehand alongside all future possibilities. Through these images we are given an account of our homeland as seen through the eye of nature itself.

Shooting pictures while hanging over the skids of a helicopter is not easy, but choosing the pictures to put in this book may have been harder. With over two thousand photographs to peruse, I was faced with extremely difficult decisions. I worried that by picking one over another I might only be telling part of a story. I witnessed so much from the air that each shot seemed to represent a special moment or unique vision of our combined struggles on the coast. I hope the photographs that were ultimately chosen will challenge you. Look at this land from a new perspective. View the clarity of how human dominance and success fare against nature's reclamations.

My flights took me through Harris County, Galveston County, Chambers County, Jefferson County, and over what little was left of Bolivar Peninsula. Many of the photographs I shot with a broken heart, hoping in the end they could help me mourn the loss of the land and the wildlife I love. What I felt as I examined them in the months following Ike was bittersweet nostalgia. I also recognized a need to share these photographs with fellow nature lovers, Texans, neighbors, and friends.

Hurricane Ike was not the first storm to make its way over the Texas Gulf Coast, but it was unlike any that I had experienced. I trust the images in this book will offer poignant testimony to an incredibly beautiful area, a hurricane's fury, and the resiliency of nature.

Acknowledgments

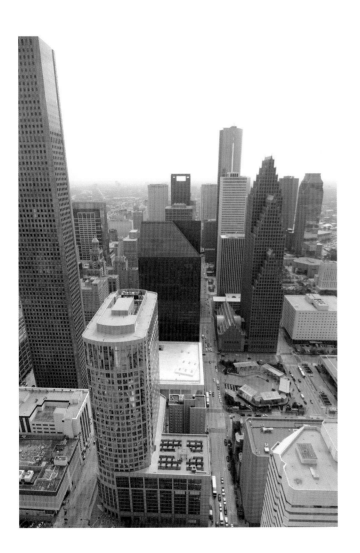

To the members of the extended Texas A&M Press family who embraced this aerial photography documentary and its production and development, and to the talents of a group of truly gifted editors, artisans, and designers, I offer my deep gratitude and humble appreciation. They saw a future in my images that I had not imagined possible.

I wish to convey a very special thanks to Andrew Sansom, who infused the essay in the book with his unique style and love for the Texas Gulf Coast, and to Lisa Llano, editor and assistant, for her technical writing skills and for keeping me focused beyond my lens.

Thank you to the members of the Carlile family who offered their unbridled support and encouragement during the creation of this book: my wife, Karen, and father, Colonel Bruce Carlile.

Unfortunately, the danger of naming names is that I might unconsciously omit someone, but this book is the result of the combined efforts of many. Thank you: Bradley Law Firm, Jim Bradley; Blackburn & Carter, Jim Blackburn; Copper Shade Tree, Gerald and Debbie Tabola; Chad Miller; National Aeronautics and Space Administration (NASA); National Oceanic and Atmospheric Administration (NOAA); U.S. Geological Survey, EROS Data Center (USGS); The San Luis Resort, Tommy Hendricks.

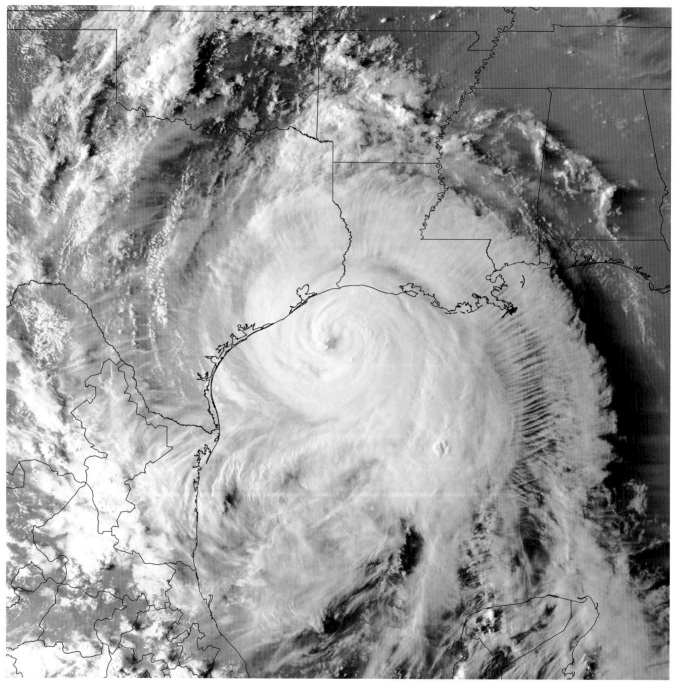

Satellite image of Hurricane Ike in the Gulf of Mexico approaching Texas, September 12, 2008, at 1:16 p.m. Central Daylight Time. Photo NASA/NOAA.

Living in Hurricane Alley

Andrew Sansom

WHERE I GREW UP in Lake Jackson on the Upper Texas Coast, hurricanes were as much a part of our lives as mosquitoes, migrating birds, oysters, and petrochemical plants. They came and went nearly every year and were, in some ways, just another aspect of our existence, enduring contributors to our sense of place. The really big ones became chronological terms of reference we used to date family events and other occasions. Hurricane Carla, for instance, which struck us in 1961, was, for many years, referred to simply as "The Storm," and weddings, funerals, graduations, and other significant experiences would be positioned in time by their relationship to its landfall. We remembered John F. Kennedy's famous speech to Congress in May of 1961, promising to put a man on the moon, as occurring in the year of "The Storm."

I remember Carla mostly as the first hurricane to truly frighten us and as the only time I ever witnessed a serious disagreement between my parents. Carla did a lot of damage to Brazoria, Matagorda, and Calhoun Counties and completely flooded the vast Dow Chemical Plant at Freeport. My father was an executive at Dow and all company employees, regardless of rank, were called to the plant after the storm had passed through to help in the cleanup. I still remember how proud he was of a photograph taken of him in overalls with a mop, swabbing the floors of the big Dow administration building.

While he was doing that, the rest of the family was struggling to put things back together at home. Our main job was to clear our large yard of an astonishing amount of debris, including fallen trees, branches, and other trash, which completely covered the property. It took my mother, my sister, and me a full week to complete this task during which we never saw my father, who slept out at the plant. Although we knew his efforts to help get the factories running again were important, we also felt somewhat abandoned at a time when we needed him most. I'm sure it was that feeling that led us to leave a little part of the yard for him to clean up when

he returned. Unfortunately our gesture inadvertently produced another kind of disaster when he made it clear to us that he did not appreciate it and, after an angry exchange, my mother got in the car and drove away.

I will never forget the anxiety I felt as a teenager wandering the rubble strewn streets of our community, still without water or power after a week, looking for my mother and hoping she was coming back. My father disappeared again, this time to try to find her, I'm sure, and I walked several miles to the home of the venerable old chief of police, desperate for help. He kindly reassured me that she would turn up and gently noted that he had a lot on his plate that day. Looking back on it, as painful as it was for us, it was nothing compared to what so many families on the Texas Gulf Coast have suffered from the storms through the years, but it was seared into my consciousness as a defining moment in my life with the hurricanes.

For every experience like mine that day, there were many more vivid and lasting examples over the years of families and neighbors pitching in to help each other in times of crisis. Distinctions of class, ethnicity, and means fell away as neighbors helped those with the most urgent needs. That is the greatest lesson we learned about the human spirit in hurricane alley.

I actually grew to look forward to the cleanups each summer and fall as opportunities to make a little spending money. I learned to use a chain saw clearing deadfall from my neighbors' yards and spent many a hot August day dragging tree branches out to the street for disposal. One particularly memorable summer, I had arranged to mow the lawn of a family in our town while they were on vacation. Before they left, we agreed on the then reasonable sum of three dollars for the work. Unfortunately, a hurricane hit us while they were gone and their place was covered with debris. I remember asking my parents what they thought I should do and the answer was "clean it up." There was not a square foot of that property that was not completely covered with tree trunks and branches. It took me a solid week to clean it up, but after I finished I mowed the lawn as promised and received full payment of three dollars when they got back.

Most of those cleanup jobs were more lucrative, thankfully, and as a teenager I maintained a little post-hurricane business, which usually earned me several hundred dollars each summer, quite a bit in those days.

Unfortunately, those late summer jobs were among the very few positive aspects of living with the hurricanes. There were some. I remember in the days leading up to landfall going down to the beach and fishing for redfish in the surf. For some reason, that was the best time to catch the really large "bull reds," which are actually spawning females of the most sought after inshore sport fish species in the Gulf of Mexico. You would stand in the water as the storm clouds gathered over the Gulf and cast into waves that were higher than your head. If you

hooked one, you had better be ready because even in normal conditions big fish like that could literally pull you in after them.

Whether fishing or not, we always went down to the beach in the days before the storms to see the awesome transformation taking place in the Gulf. Long before a hurricane would reach the Texas coast, majestic swells along the shore reached a volume and intensity that dwarfed normal surf conditions, warned ominously of what was coming, and reminded us of our mortality.

Back away from the beach, an eerie feeling of unreality would settle over us, giving meaning to the term "calm before the storm." It always seemed to me that time would slow down and we would experience our preparations as if we were watching ourselves getting ready for the hurricane in a movie.

The closer the storms came, the more barren the shelves in the stores would be as we stocked up on canned foods, bottled water, batteries, and everything we thought we would need to be prepared. Standing in line at the cash register, customers swapped hurricane tales and observations. If several years had passed since the last big one, people seemed to forget how deadly they could be and you would hear comments like "I've never run from a storm. They are never as bad as the television says they are going to be, and I'm staying right here."

To date, several hundred people who stayed in Galveston and on the Bolivar Penninsula during Hurricane Ike are still missing.

You failed to respect the hurricanes at your own peril, and oftentimes the many false alarms produced a misplaced complacency that lulled those who hadn't actually been through one into a false sense of security. In 1983, anticipating the arrival of Hurricane Alicia, I spent hundreds of dollars on plywood, boarded up all my windows, and actually broke one out accidentally with a hammer. After finishing the windows, I put my wife, kids, and dog in the truck and headed for my in-laws in Houston. It took us six hours to make a forty-five mile trip in the evacuation and, as it turned out, the storm missed our house completely. The only damage we suffered was the window I broke out while nailing up plywood. I remember thinking as we headed back to the coast that the whole fiasco could well lead to more loss of life in the future because folks would be less likely to run the next time.

The smart ones always ran.

I had a great friend who lived in the Village of Quintana at the original mouth of the Brazos River, about five hundred feet from the beach. Quintana is where the first Anglo colonists arrived in Texas, and Woody Erwin's family had been there for generations. Woody was an operator in the big Monsanto plant on Chocolate Bayou between Brazoria and Galveston Counties, and he had a legendary reputation of being able to accurately predict where a hurricane would come to shore.

In the days preceding Hurricane Allen in 1980, I went out to Quintana to visit with Woody and learn

how he did it. This was before the sophisticated storm tracking of today, and Allen was so large that it covered the entire Gulf of Mexico on the satellite photos. Needless to say, I was more than a little bit interested in where the huge storm was going to come in, and I sat on Woody's front porch watching the surf grow while he checked his barometer, thermometer, and wind gauge. According to Woody, Allen would make landfall just north of Port Mansfield on the Laguna Madre.

He called it exactly. The giant hurricane went ashore right where he said it was going to, more than three hundred miles south of Quintana and, due to the sparse population of South Texas, caused little damage. What I remember most, though, about Hurricane Allen and my encounter on the beach with Woody was that, in spite of his well-deserved reputation and confidence in his predictions, when we finished our conversation he packed up his family and left.

Running from the storms was a big part of the experience, as recent images of the massive traffic jams ahead of Rita and Ike have attested. Normally, growing up, we would run to my grandparents' house in Huntsville to wait them out. It was kind of a treat to get out of school for a while and visit with loved ones, but it would usually get old pretty quickly because even that far inland, it rained every day until the hurricane had passed.

My own children were young when we ran from Alicia, escaping to Houston. But the storm missed our home on the coast and scored a direct hit on the bayou city where we were holed up. Our most vivid memories of Alicia were of being hunkered down, listening to the howling wind and rain for hours, and then walking outside and experiencing the surreal stillness and sunshine as the eye of the storm passed over our heads. After maybe an hour, we went back into the house and listened for the return of the hurricane gale, which came at us again like a locomotive.

Returning home was an experience of anxiety, fascination, and mystery. I remember coming back after Carla and encountering water on both sides of the road as far as you could see, more than twenty miles from the Gulf. I saw a shrimp boat aground near Angleton, more than twenty-five miles from the beach. Dead cattle lay everywhere in the fields. The roads in those coastal bottomlands near the Brazos and Colorado Rivers are generally built up a little higher than the surrounding countryside, and all the way home we passed hundreds of snakes and other creatures up on the shoulders and out of the floodwaters.

Closer to the Gulf in the vast coastal prairies, a slight elevation of maybe eighteen inches was known as a "ridge." Old timers in the area still tell of the refuge provided by these near negligible uplands to everything from deer to snakes to coyotes and virtually every other member of the animal kingdom that clustered together in a kind of dryland truce until the waters subsided and the relationship of predators and prey could resume.

It was always the flooding that worried us the

most since I grew up on the banks of Oyster Creek and lived later along Buffalo Camp Bayou. Rainfall from the hurricanes would swell these lazy coastal streams to raging torrents that inched closer and closer to the house. After one particularly wet monsoon, my wife, Nona, returned to our home on the bayou to rescue the family cat, whose name was Casper. She couldn't get anywhere near the house in the car because the flood-waters were still more than waist deep. She managed to hitch a ride in a high-wheeled truck, which got her a little closer, but ultimately had to do the last quarter mile on foot. The house, which stood on pilings, was still dry, as was the cat, but as Nona waded several hundred yards back to the car with Casper in her arms, he panicked at the sight of all the water around him, embedded his claws into her shoulder and scrambled up on top of her head, where he stayed until they reached dry ground.

There were many other hazards in these wet homecomings, including live wires in the water from downed power lines and large colonies of fire ants that sailed along in the floodwaters in great clumps, bringing agony to anyone unlucky enough to be in their path.

The first thing to do when we got in the house was to empty the refrigerator because the contents were most likely spoiled or soon to be so. And often, because there was usually no water or power, after checking on things we would pile back in the car and head inland for a few more days until the community became habitable again.

We were lucky to have something to come back to.

Whenever I think about returning to a refrigerator full of spoiled food, I think of the thousands who have returned to find no refrigerator at all . . . and often, no home. Every time I think of how frightened I was when I thought my mother had left for good, I think of the thousands of people who have never come back . . . and many who have never been found.

It is all a matter of perspective, and Bryan Car-lile here presents us with the unique and stunning viewpoint of a first responder, having begun to shoot these sobering photos the day after Hurricane Ike made landfall at Galveston. To behold the devasta-tion depicted in these images is to understand that only two other storms in the history of the United States have been more destructive. At least 195 people died in the storm and its aftermath, and total damages in the United States alone are estimated to be $24 billion. For the second time in its history, Galveston has suffered a hit from which it may never recover. At the least, the island city and its rich his-tory and culture have once again been changed forever. The first time, in 1900, Galveston was struck by a hurricane that still today is the largest human disaster in American history, having killed six thou-sand people. It was exceeded in total destruction only by Hurricane Katrina in 2005. In fact, the 1900 storm; Hurricane Camille, which bombarded the mouth of the Mississippi River in 1969; and Katrina are the three worst Gulf hurricanes to occur since the nineteenth century.

I lived on the Texas coast during one of two major periods of hurricane activity in the Gulf. Between 1960 and 1980, ten very large hurricanes made landfall on the coast. The first cycle was from 1900 to 1920, when eleven major storms came ashore.

Today, three of the nation's largest metropolitan areas lie on the Gulf Coast: Tampa, New Orleans, and Houston. It is estimated that there is more than $500 billion in insured property built between Texas and the Florida panhandle, and though the losses thus far have been enormous, we continue to encourage and subsidize even more development squarely in the path of these great natural behemoths.

The beach is quiet after a hurricane, and as I walked along the coast after Ike, I thought of Ozymandias, whose history Shelley captured nearly two hundred years ago in just fourteen lines, along with that of the civilization he ruled in the timeless hubris of humanity:

> *I met a traveller from an antique land*
> *Who said: Two vast and trunkless legs of stone*
> *Stand in the desert. Near them on the sand,*
> *Half sunk, a shatter'd visage lies, whose frown*
> *And wrinkled lip and sneer of cold command*
> *Tell that its sculptor well those passions read*
> *Which yet survive, stamp'd on these lifeless*
> *things,*
> *The hand that mock'd them and the heart that*
> *fed.*
> *And on the pedestal these words appear:*
> *"My name is Ozymandias, king of kings:*
> *Look upon my works, ye mighty and despair!"*
> *Nothing beside remains: round the decay*
> *Of that colossal wreck, boundless and bare,*
> *The lone and level sands stretch far away.*

Walking on the beach in solitude amid the wreckage after a hurricane brings a sense of loss, of survival, of one's own insignificance, and of life beginning again. There is renewal in the marshes, estuaries, and other natural systems along the coast that comes from having been thoroughly flushed by wind and water, not unlike the cleansing power of wildfire on upland prairie. In the aftermath of such trauma, both humanity and nature somehow rebound, undeterred by the reality that there will be more storms to come.

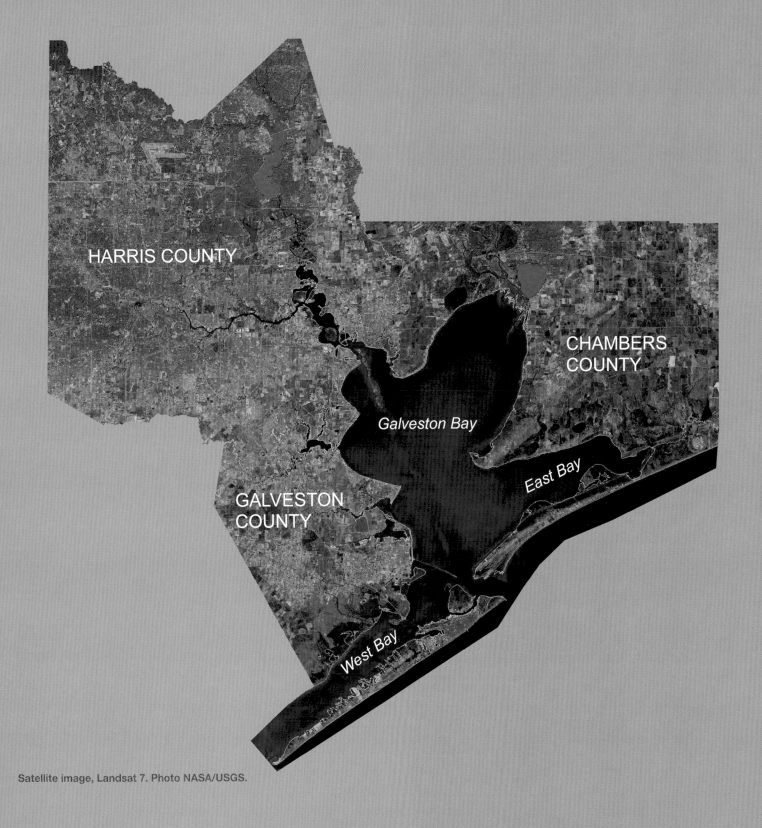

HARRIS COUNTY

CHAMBERS
COUNTY

Galveston Bay

GALVESTON
COUNTY

East Bay

West Bay

Satellite image, Landsat 7. Photo NASA/USGS.

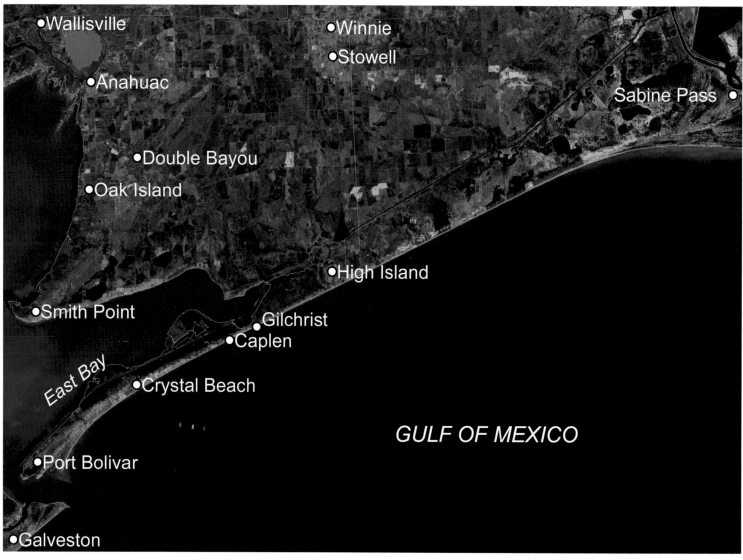

Wallisville • Winnie •

 Stowell •

Anahuac • Sabine Pass •

Double Bayou •

Oak Island •

High Island •

Smith Point •

 Gilchrist •
Caplen •

East Bay

Crystal Beach •

GULF OF MEXICO

Port Bolivar •

Galveston •

Hit by Ike's most intense or "dirty" side, Bolivar Peninsula in Galveston County and two coastal counties of the Upper Texas Coast, Chambers and Jefferson, received the full brunt of the hurricane's wind and storm surge. *Satellite image, Landsat 7. Photo NASA/USGS.*

PART 1

Bolivar Peninsula & Chambers & Jefferson Counties

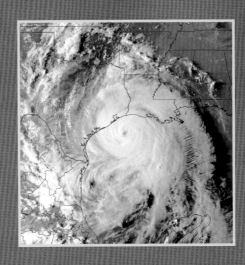

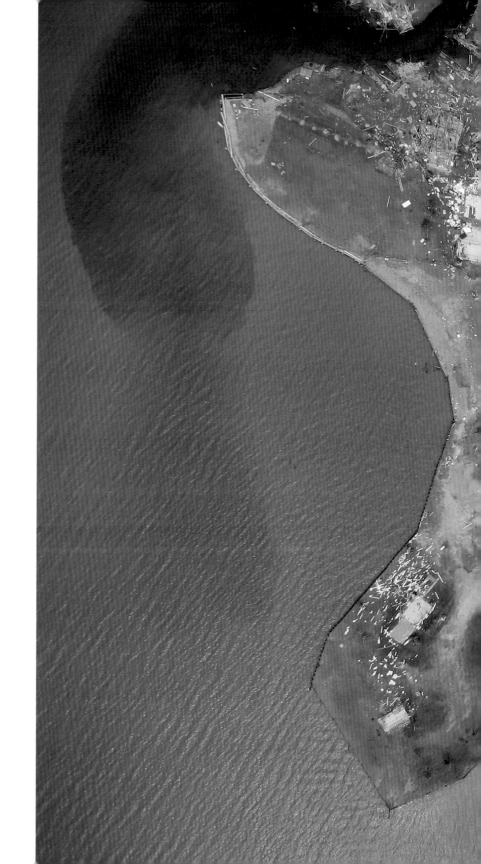

Remains of the community of Oak Island on
Trinity Bay in Chambers County.

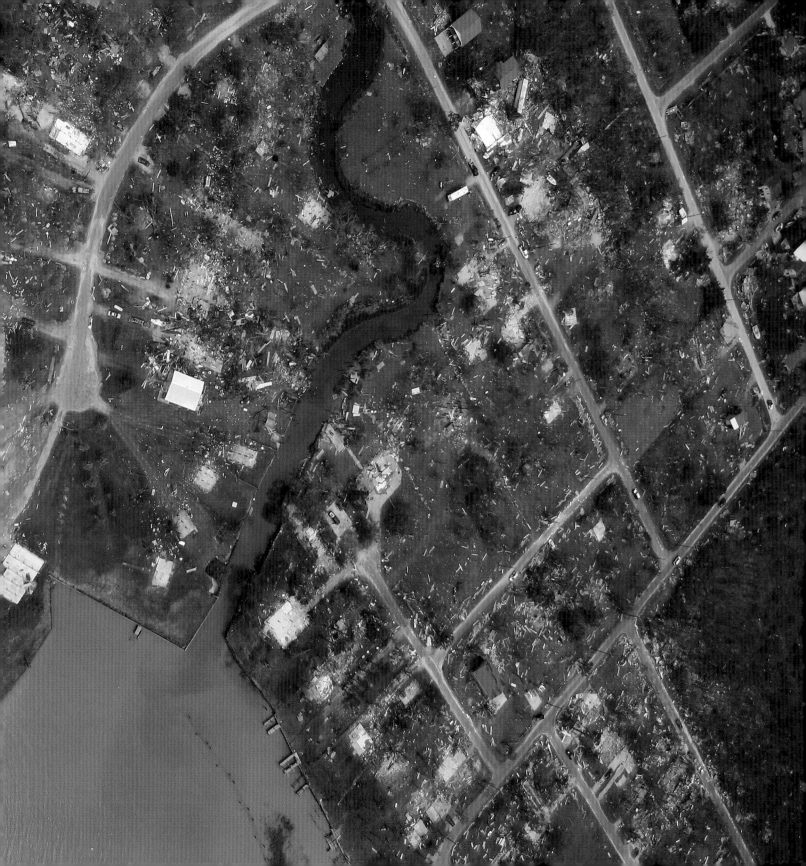

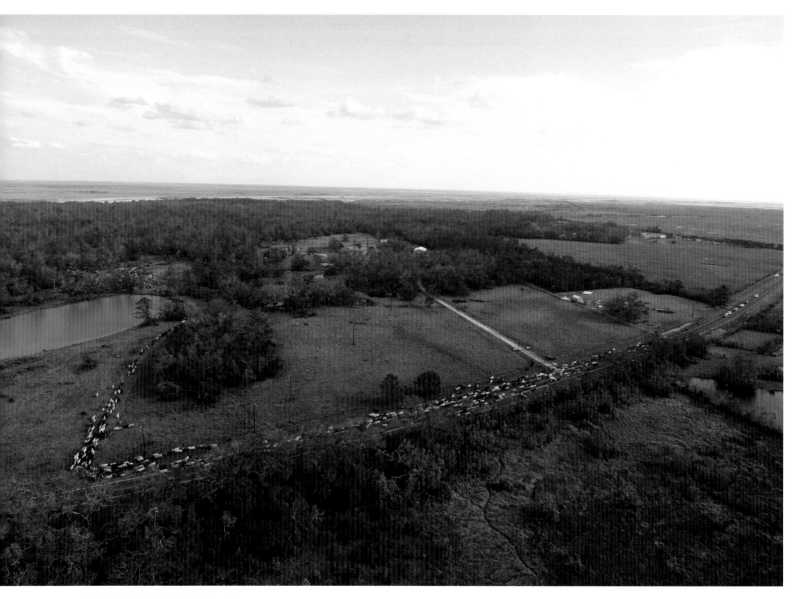

Cattle drive, Chambers County.

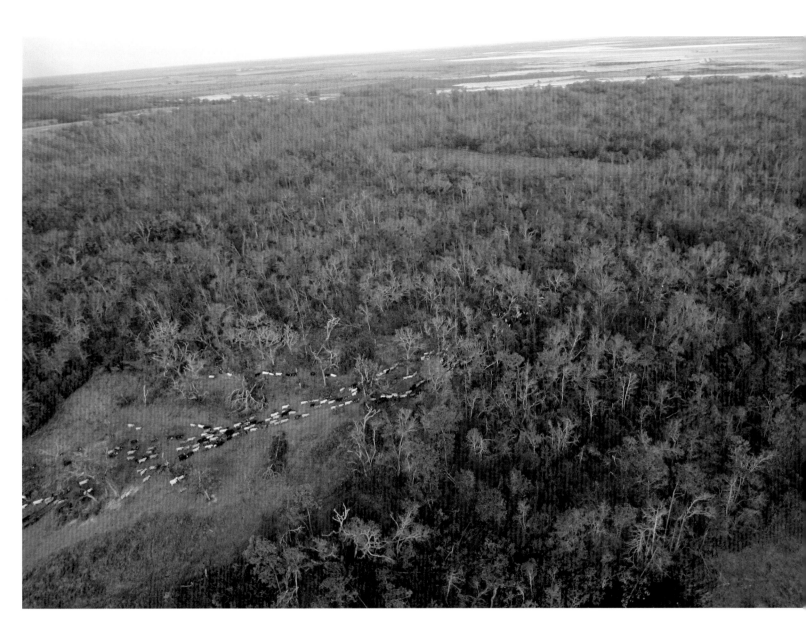

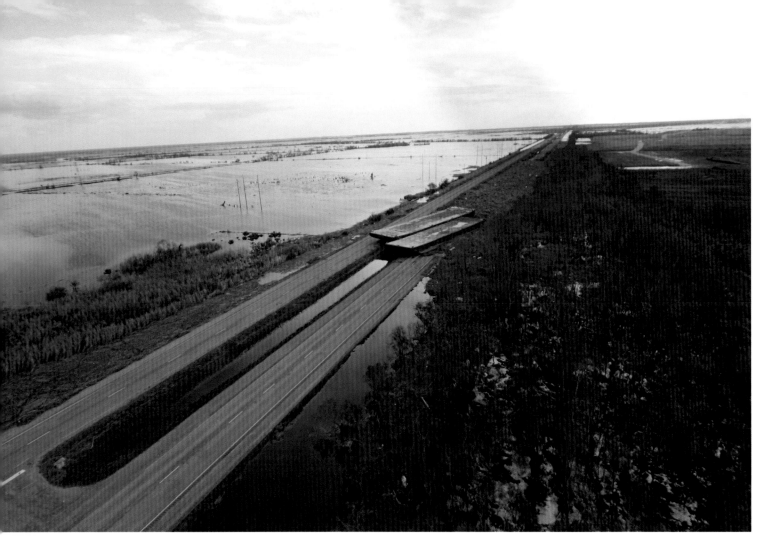

Barges transported by the storm surge onto a roadway near the town of Winnie.

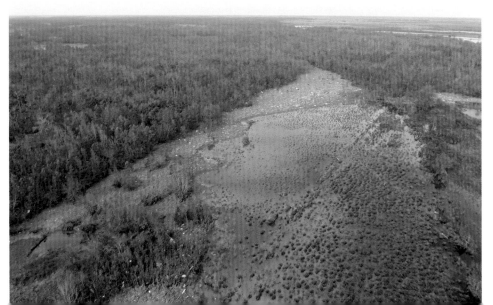

Debris field from the storm surge extending north of East Bay into Chambers County.

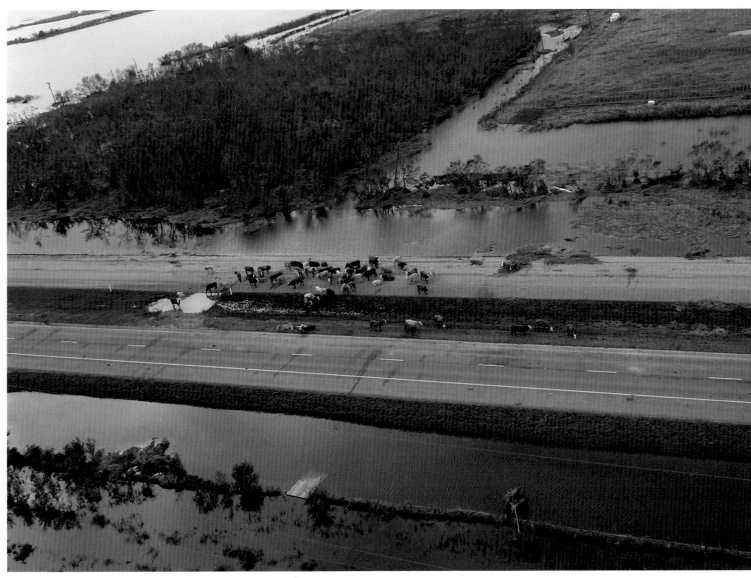

Stranded cattle near Winnie.

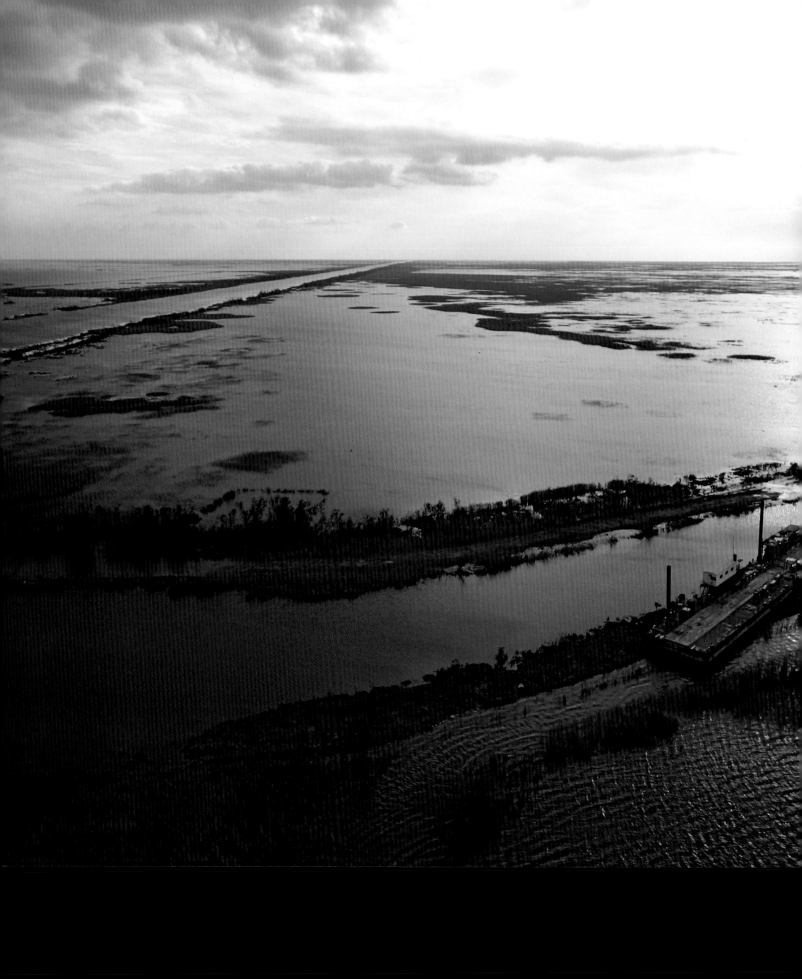

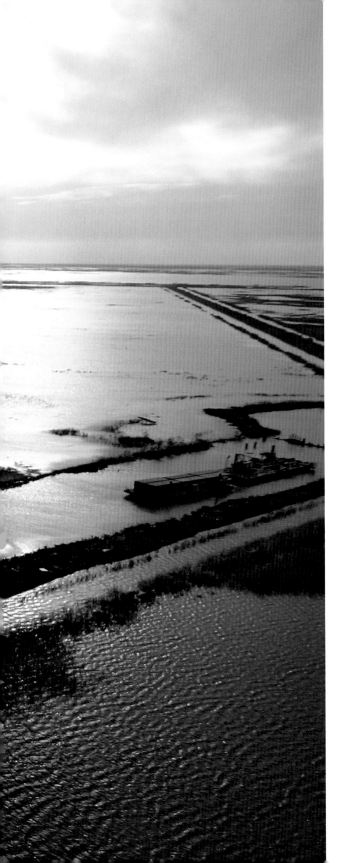

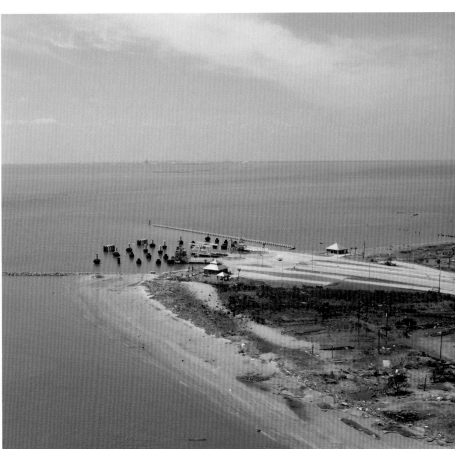

Port Bolivar ferry landing.

Barge grounded near Winnie.

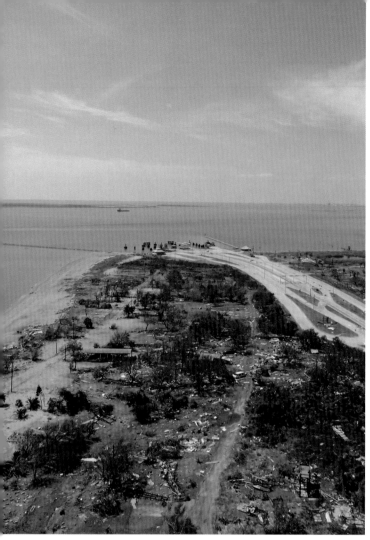

Port Bolivar.

Houston Audubon Society Bolivar Flats
Shorebird Sanctuary.

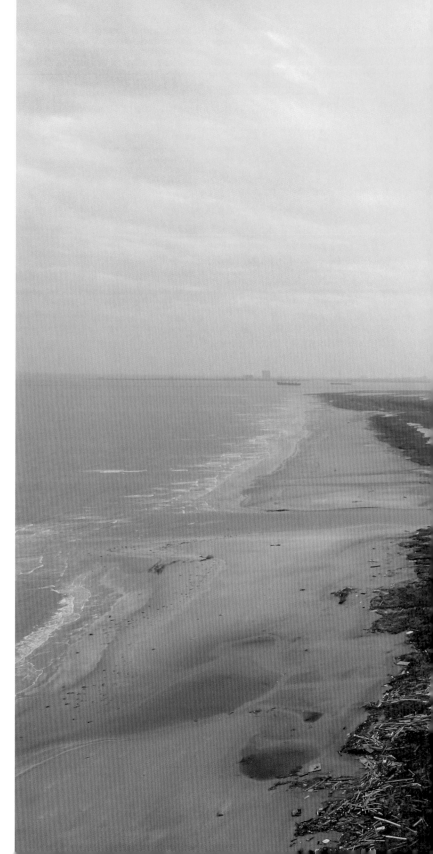

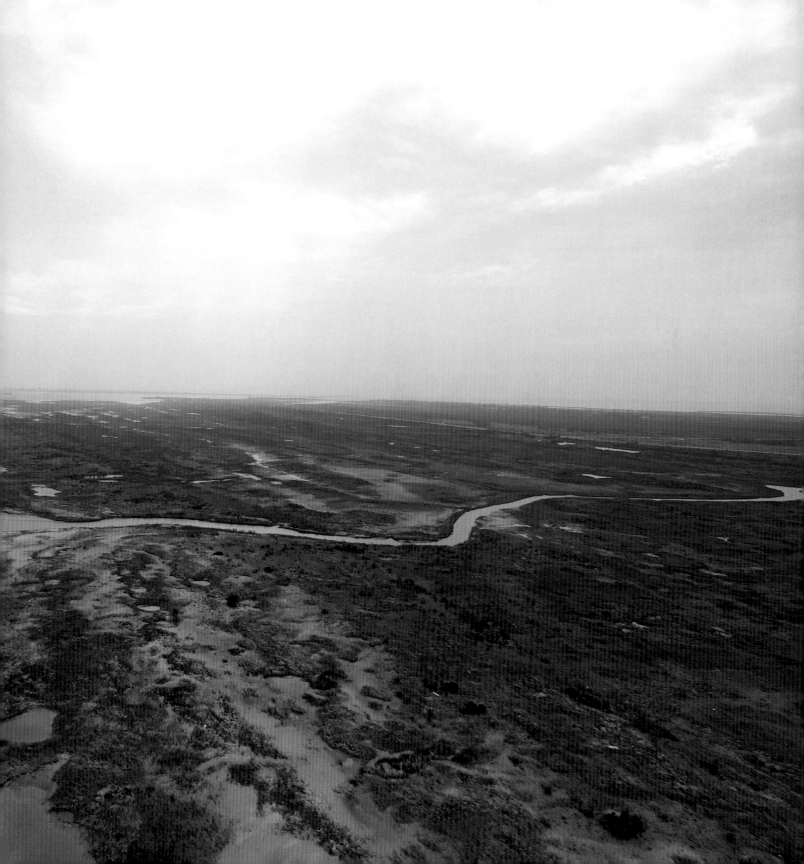

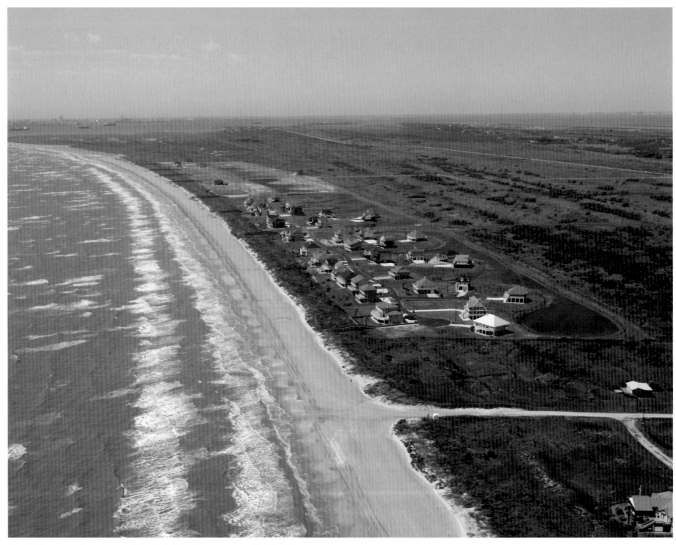

Aerial image of a new residential development on the Bolivar
Peninsula coastline taken in April of 2007, before Ike.

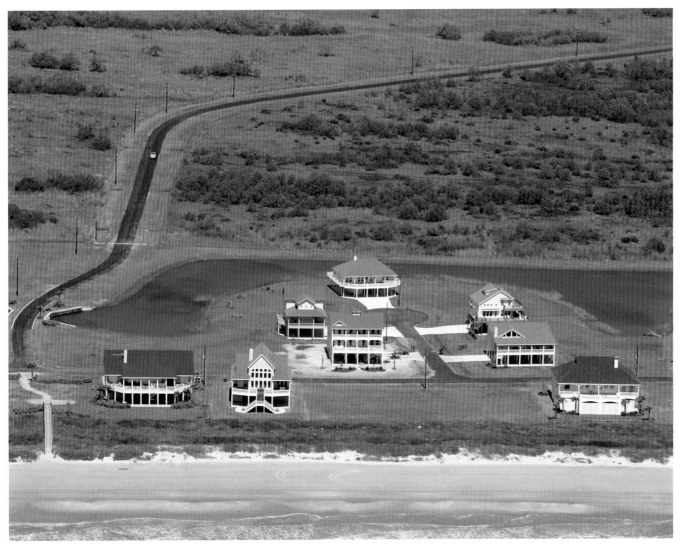

New development in April 2007, before Ike.

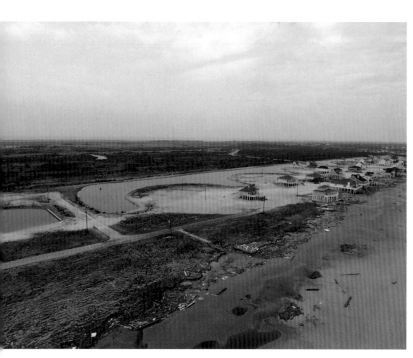

New development after Ike.

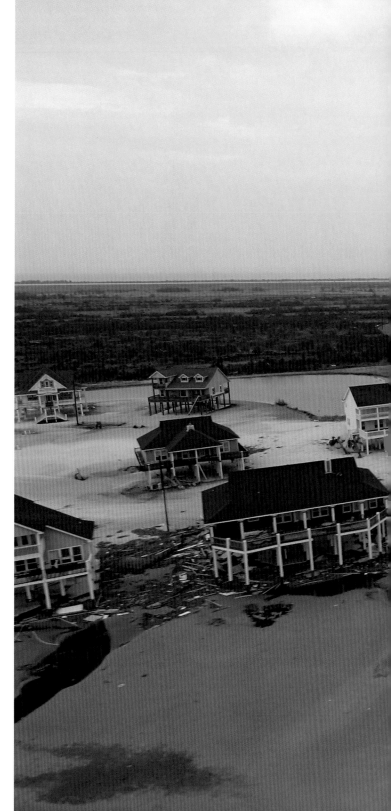

New development after Ike.

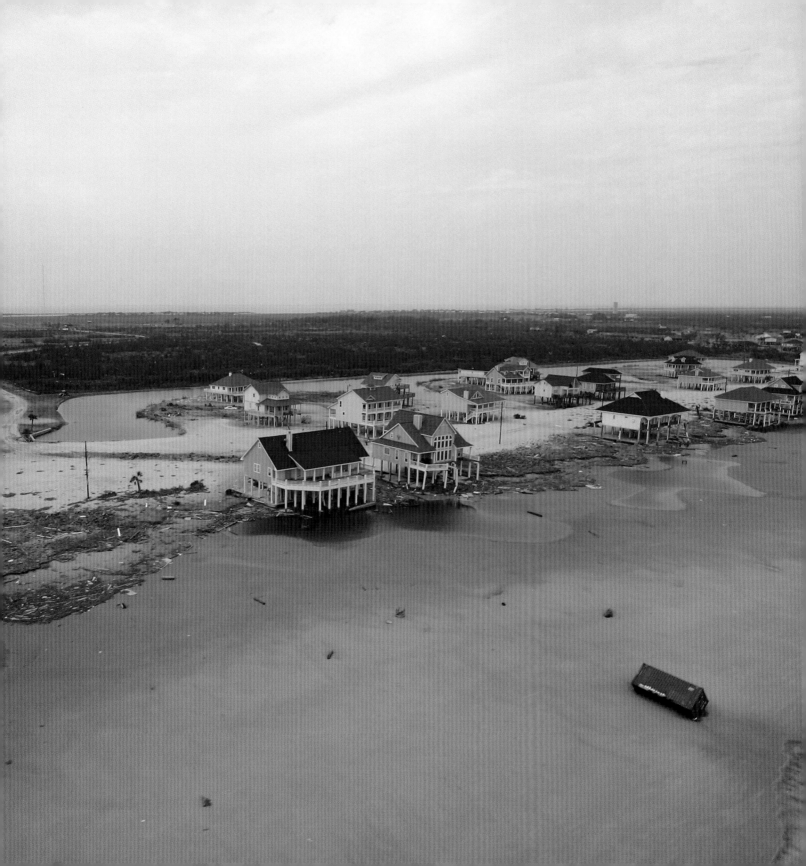

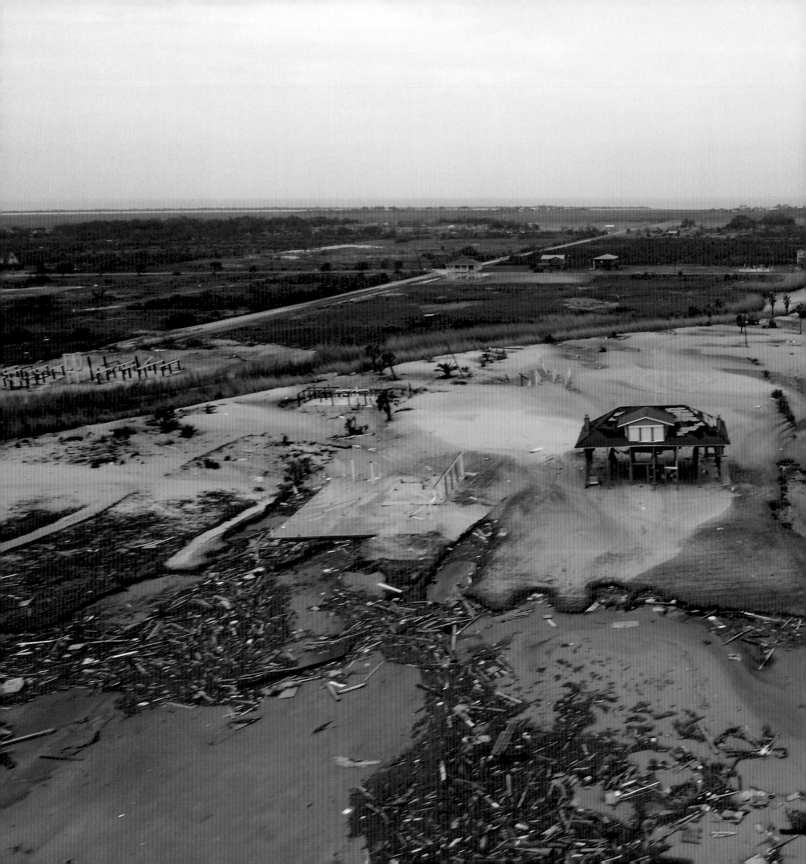

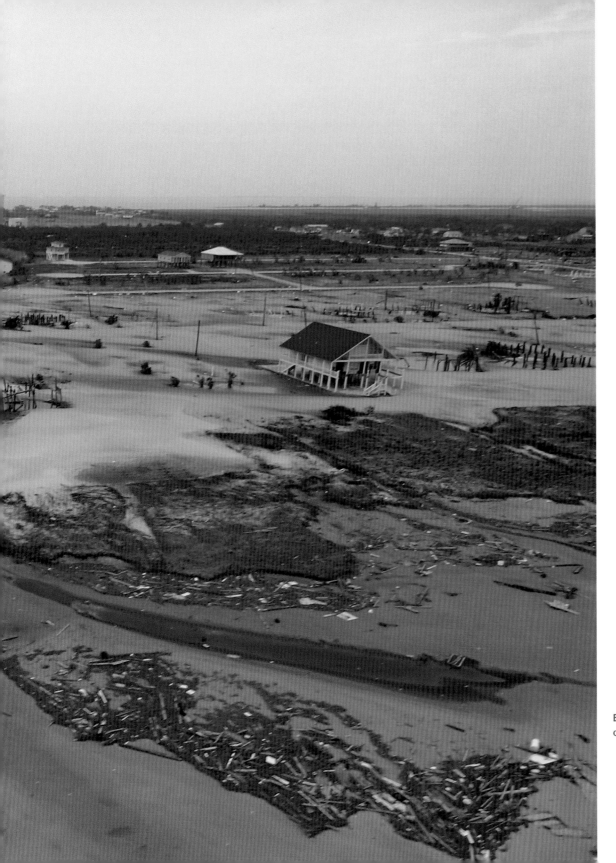

Bolivar Peninsula
coastline.

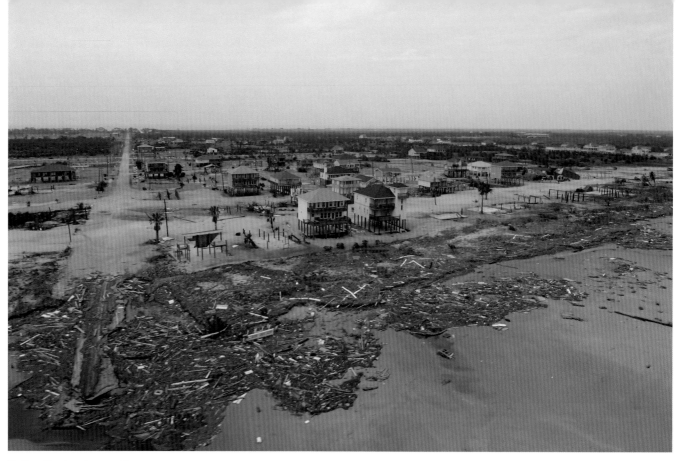

Bolivar Peninsula coastline.

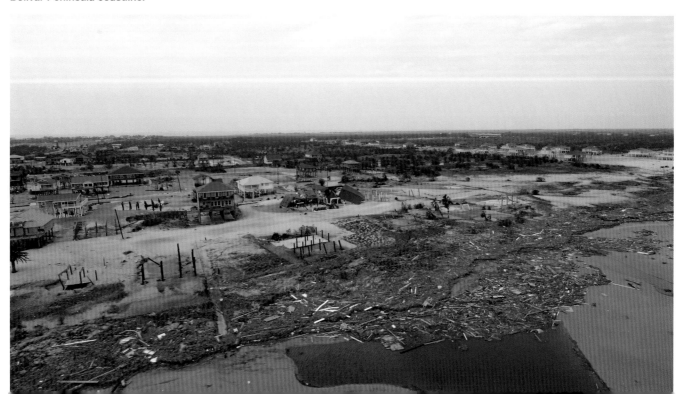

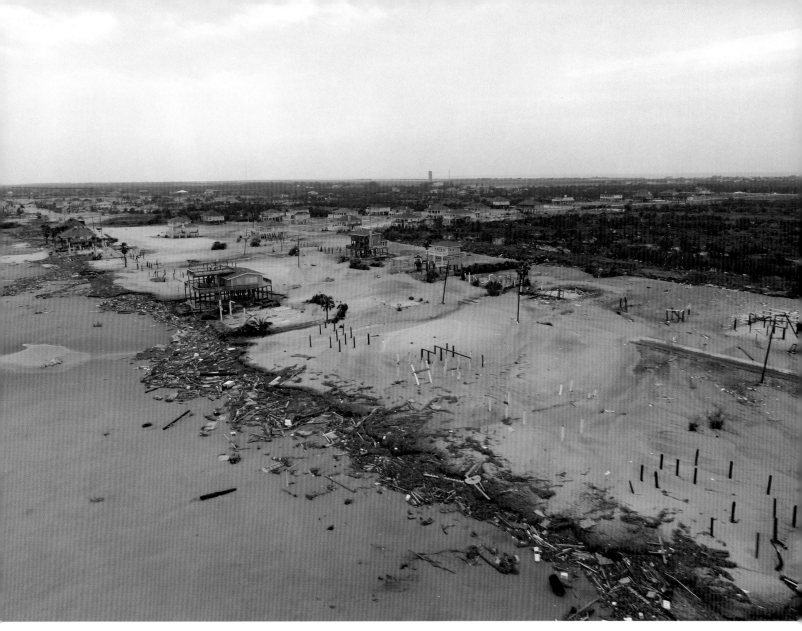

Bolivar Peninsula coastline.

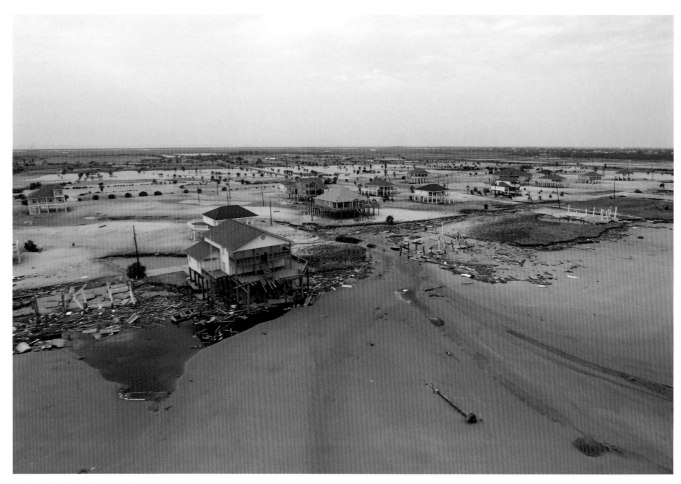

Bolivar Peninsula coastline.

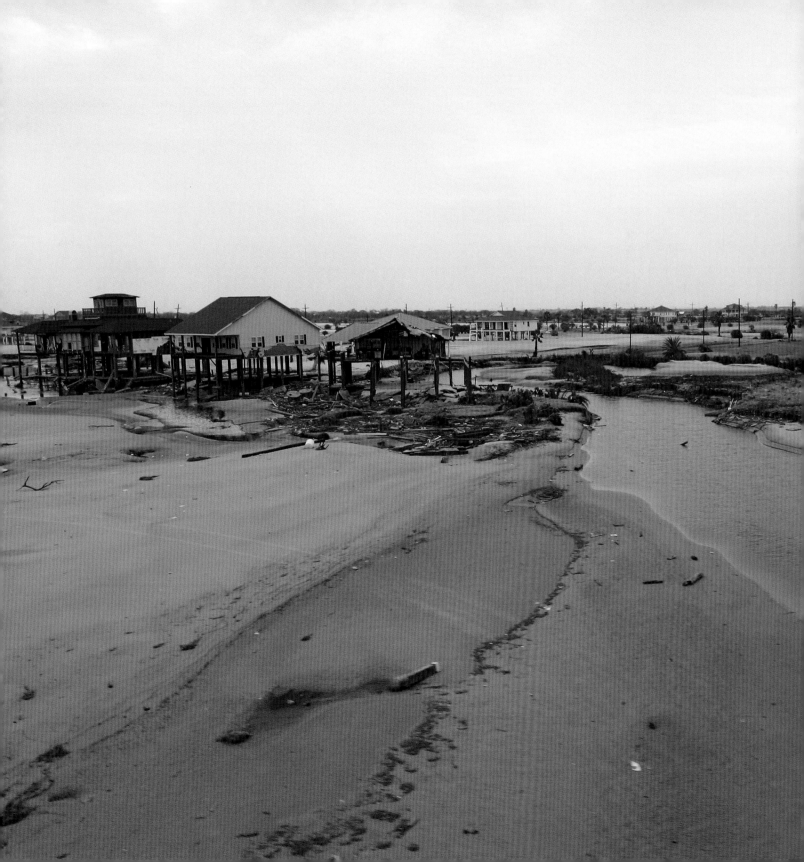

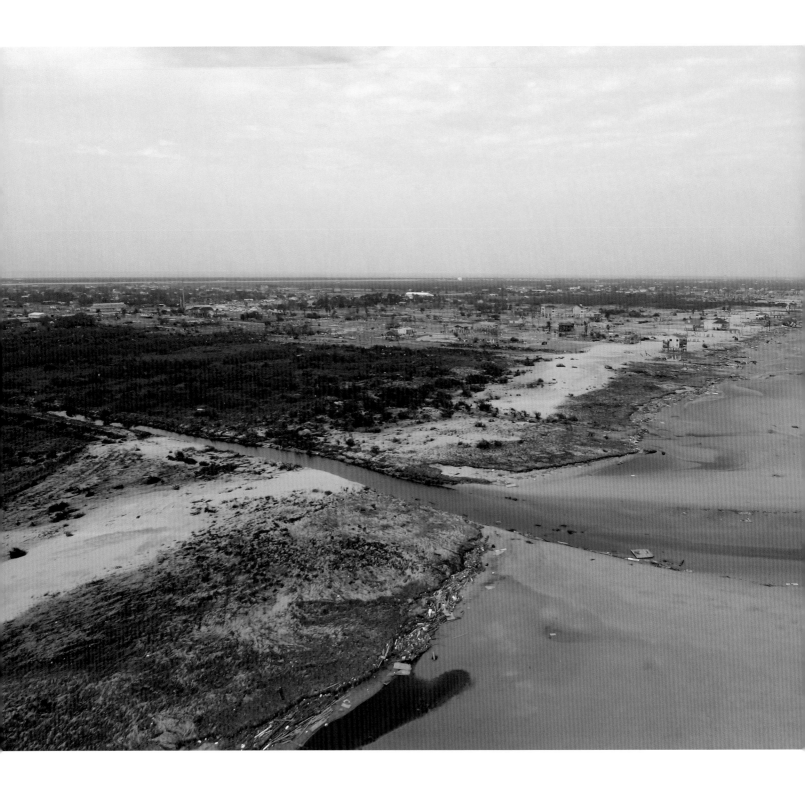

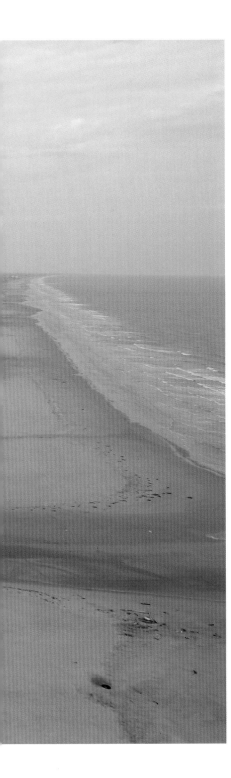

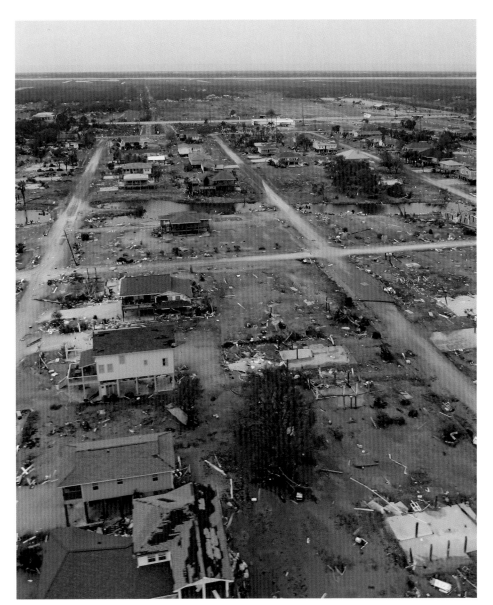

Bolivar Peninsula coastline.

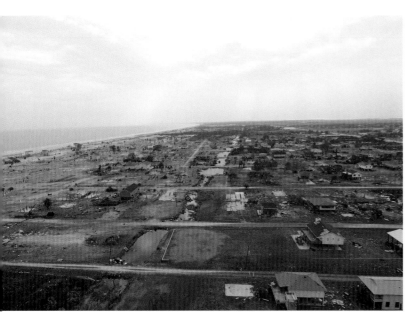

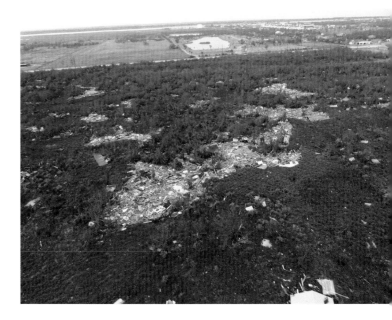

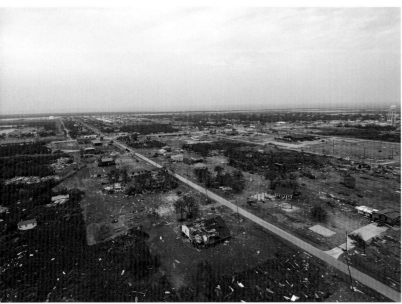

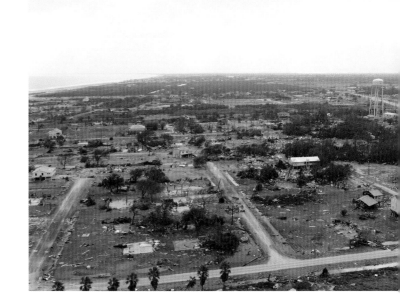

Crystal Beach.

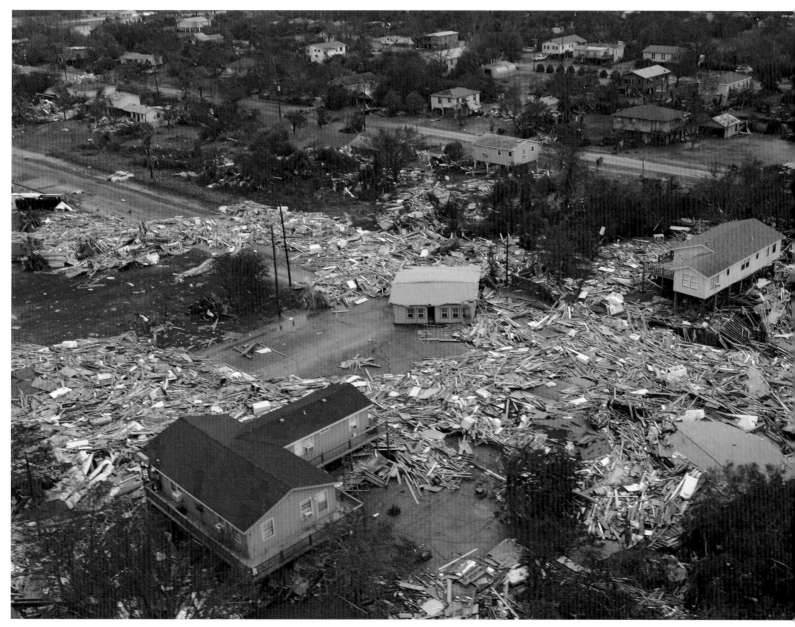

Crystal Beach.

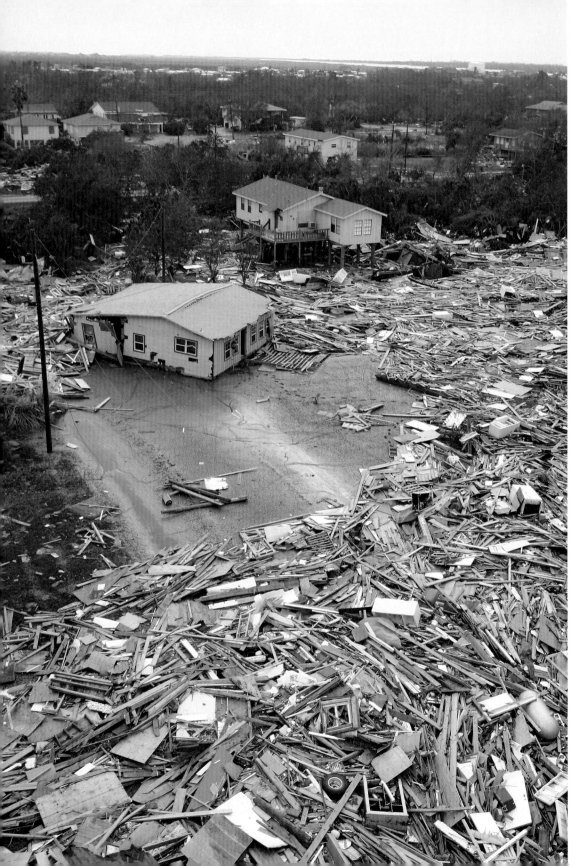

Crystal Beach.

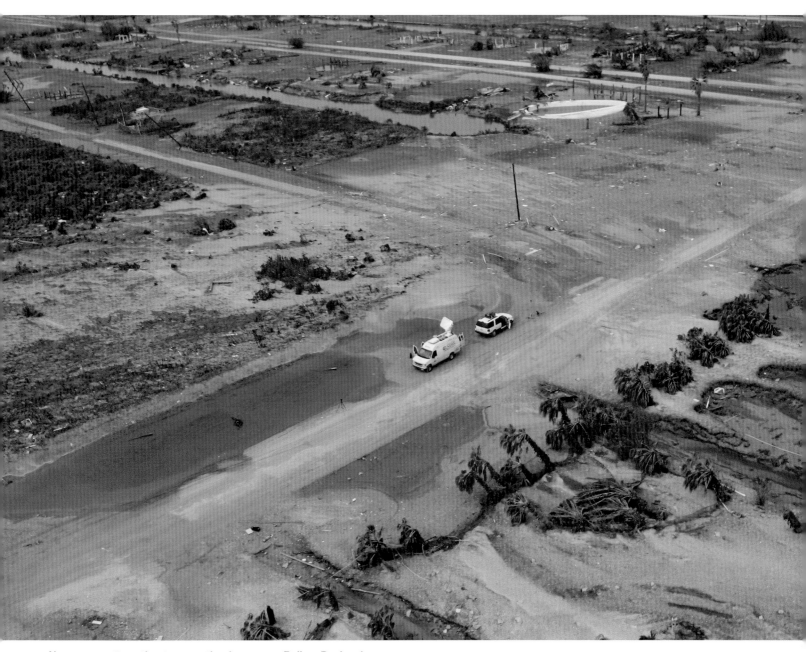

News crew attempting to cover the damage on Bolivar Peninsula.

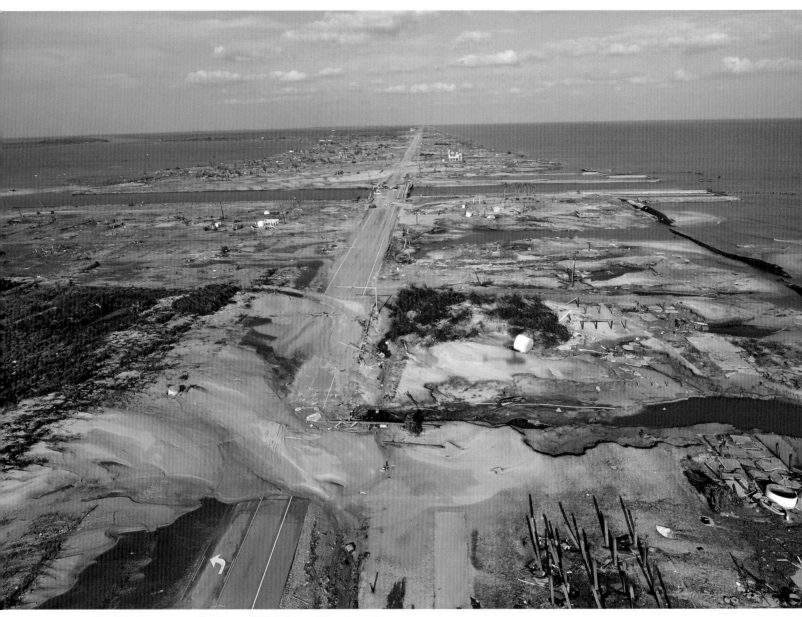

Coastal damage near the town of Gilchrist and the channel Rollover Pass.

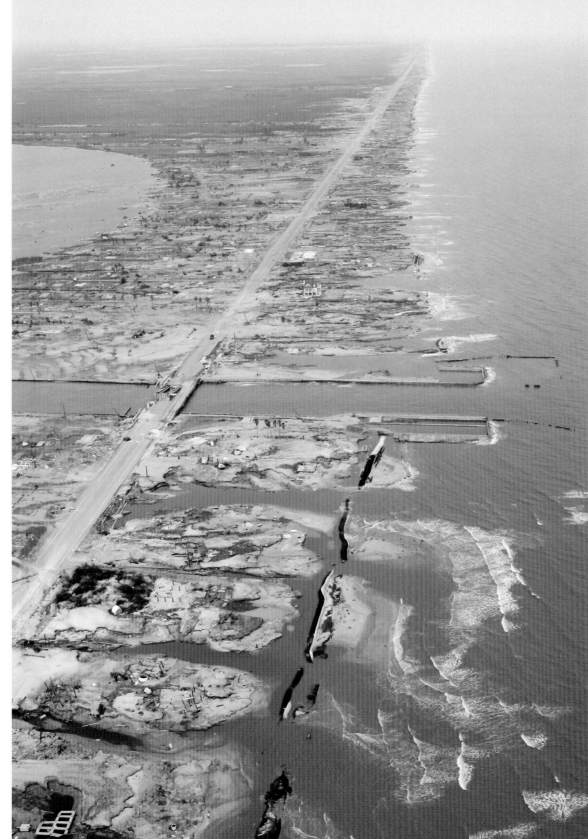

Gilchrist and
Rollover Pass.

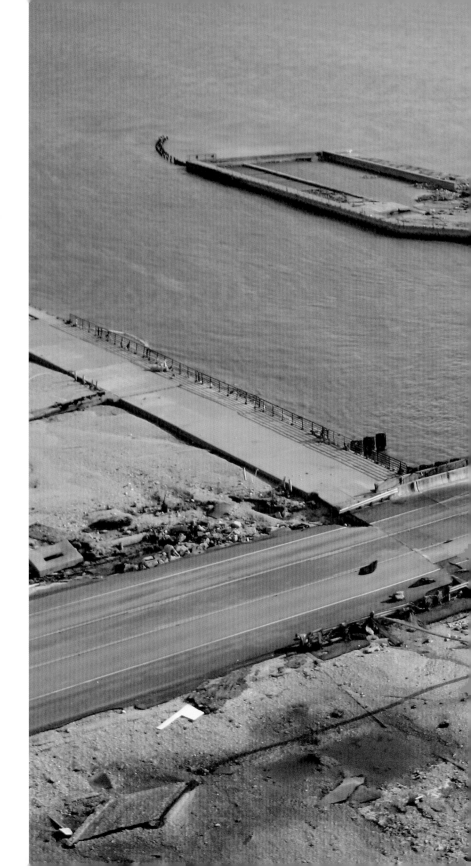

Gilchrist and Rollover Pass.

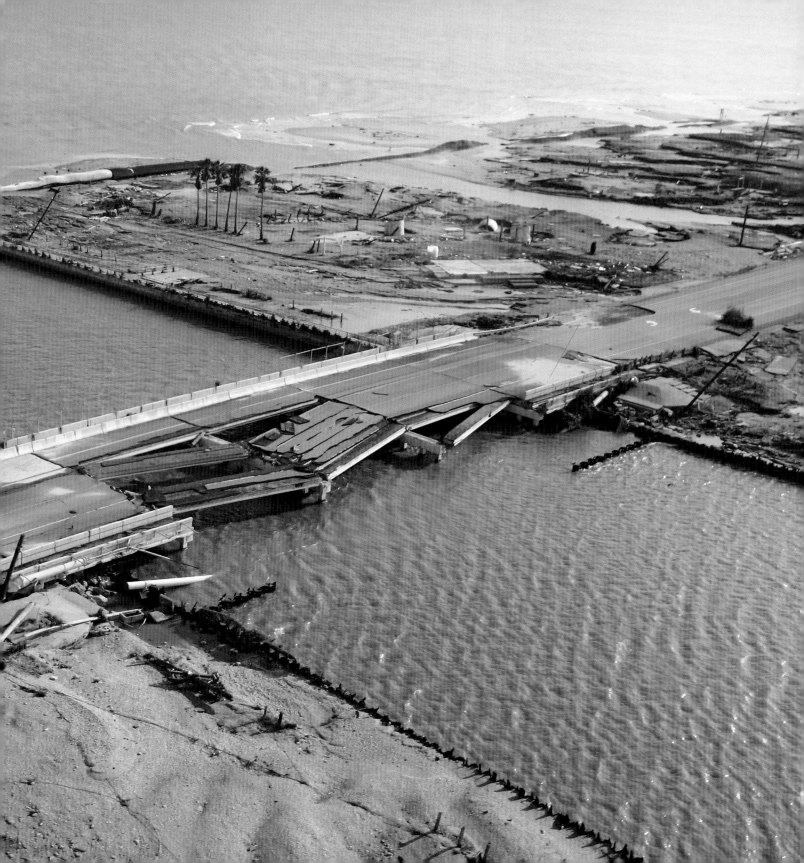

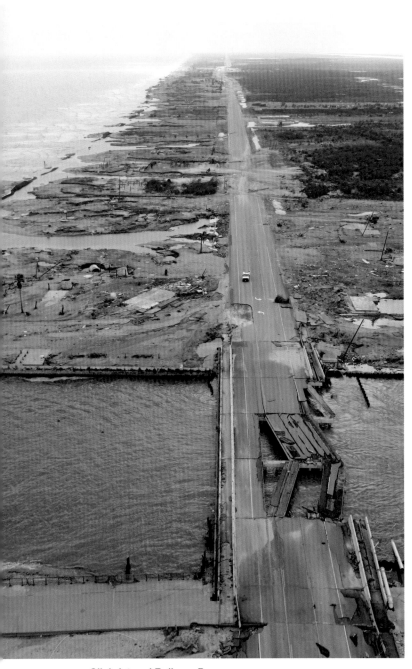

Gilchrist and Rollover Pass.

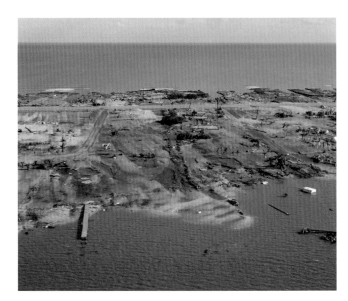

Gilchrist.

Gilchrist.

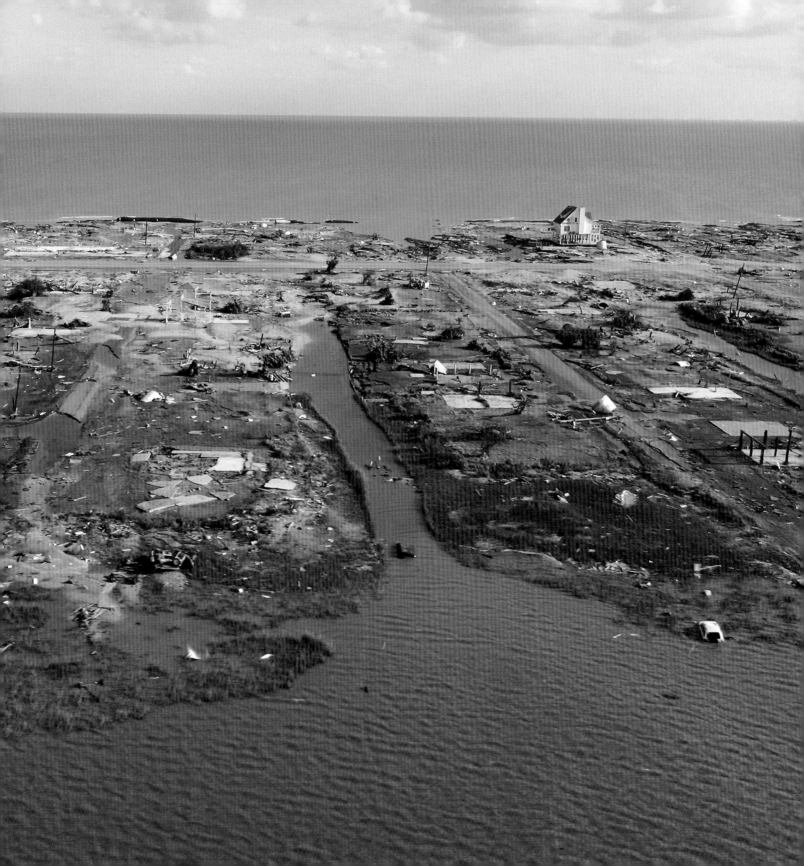

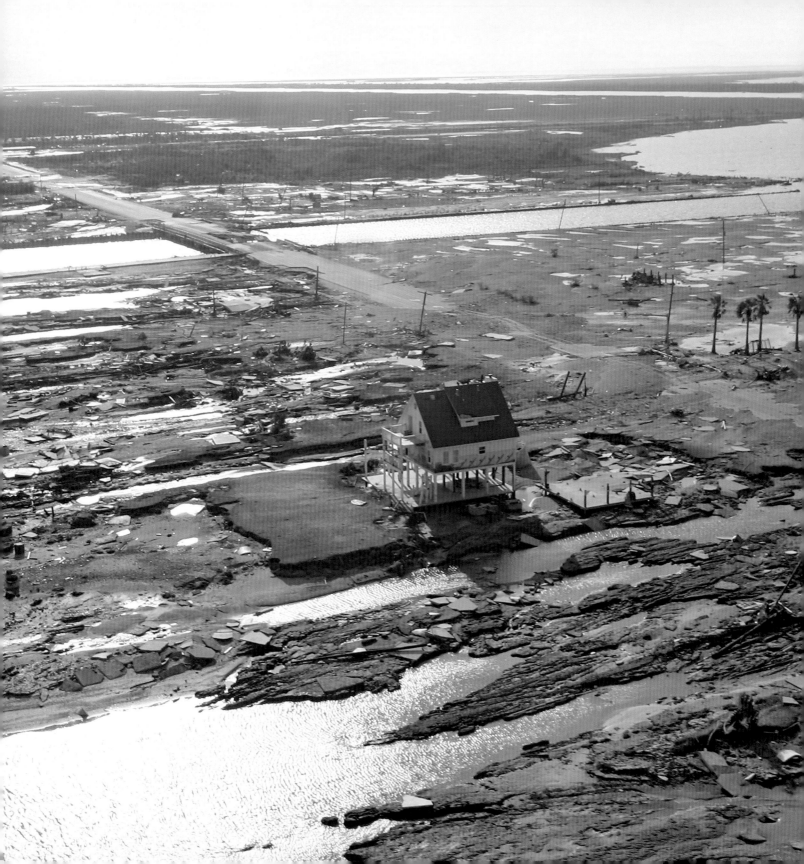

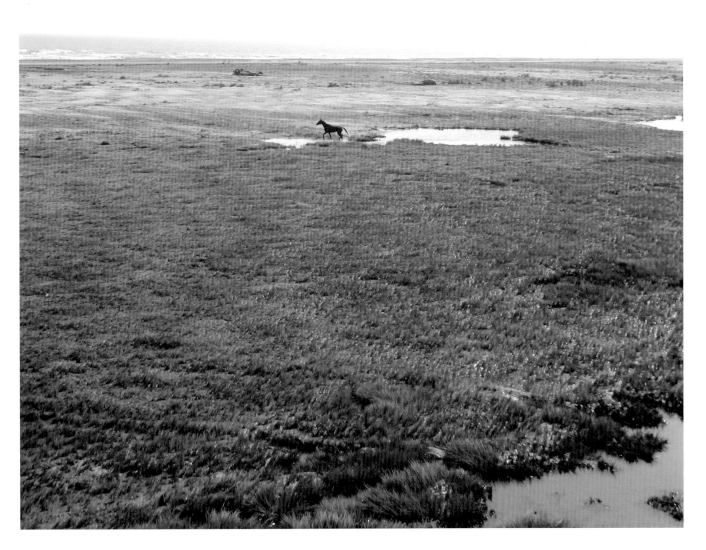

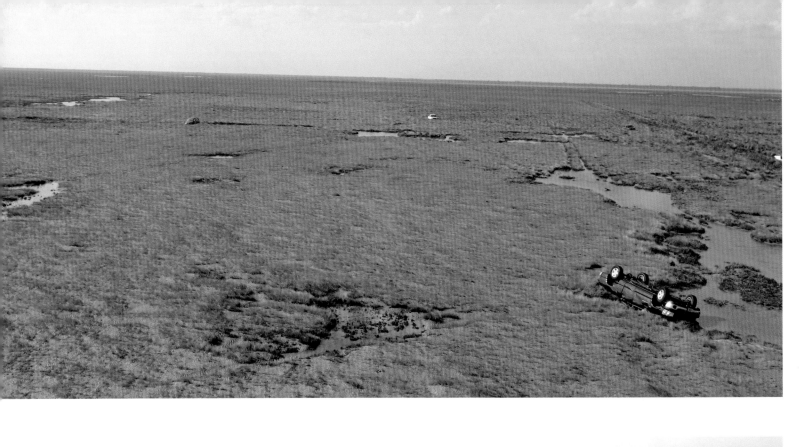

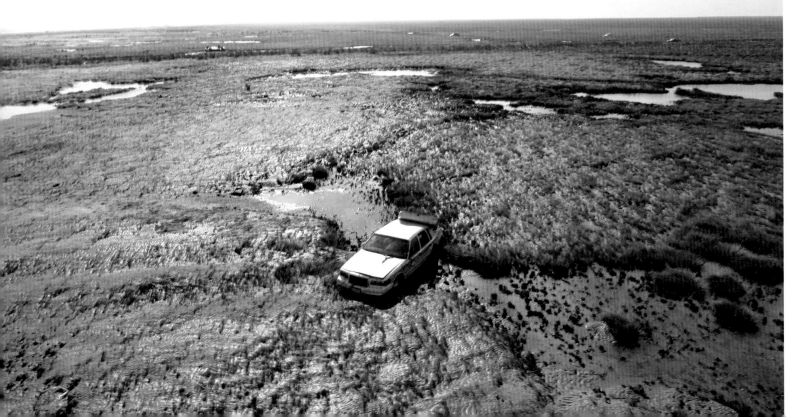

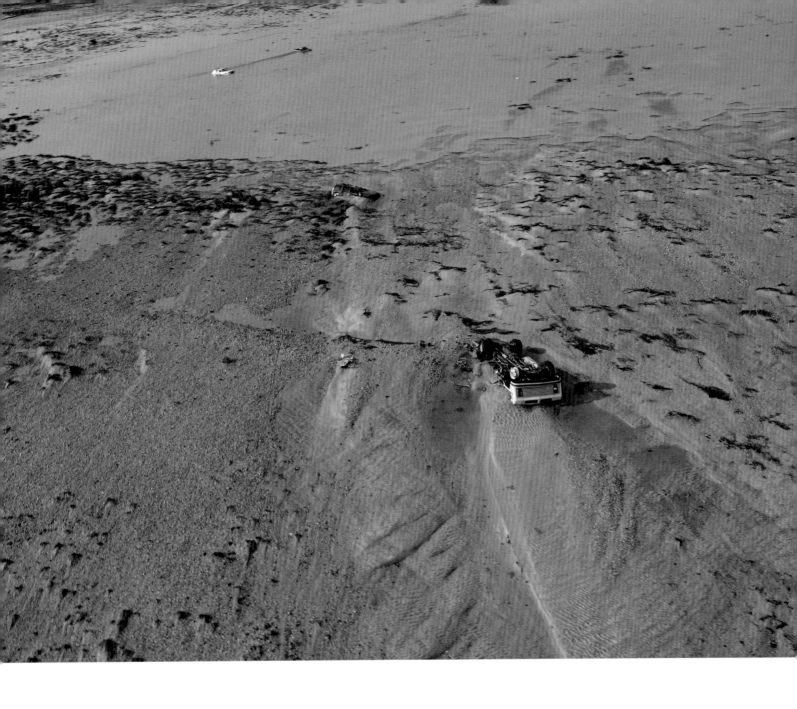

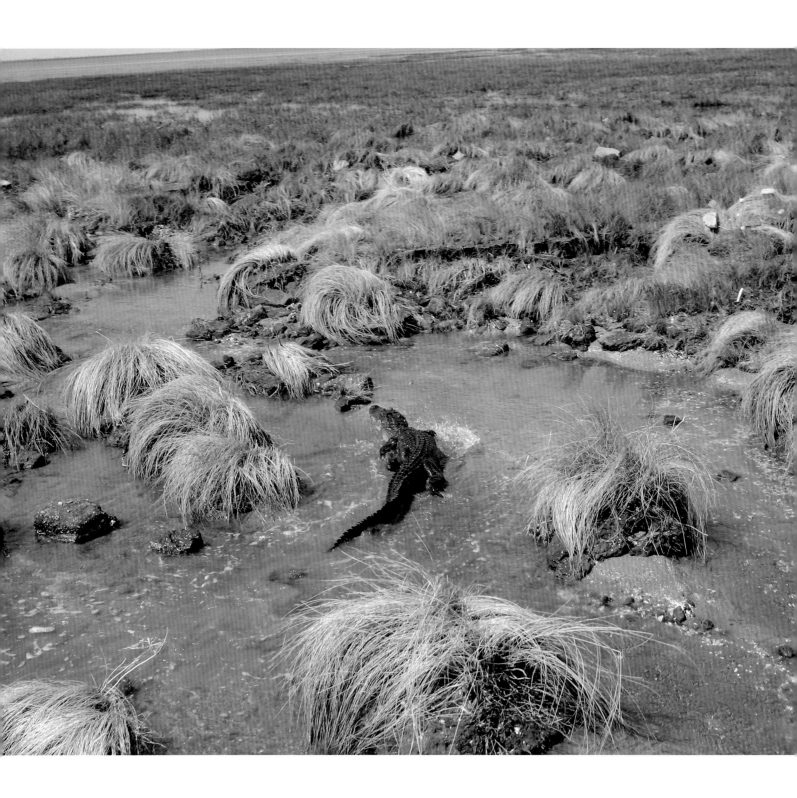

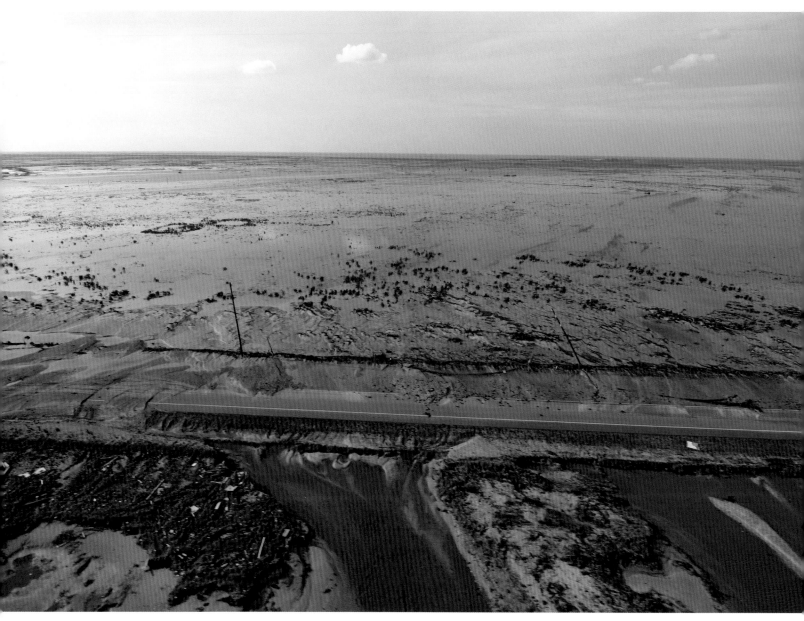

State Highway 87, near High Island.

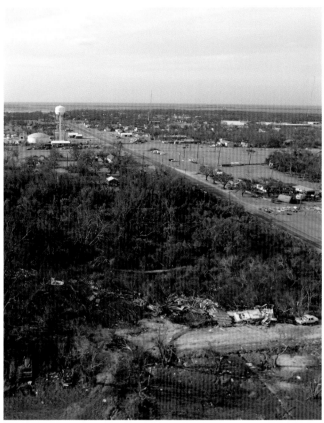

High Island.

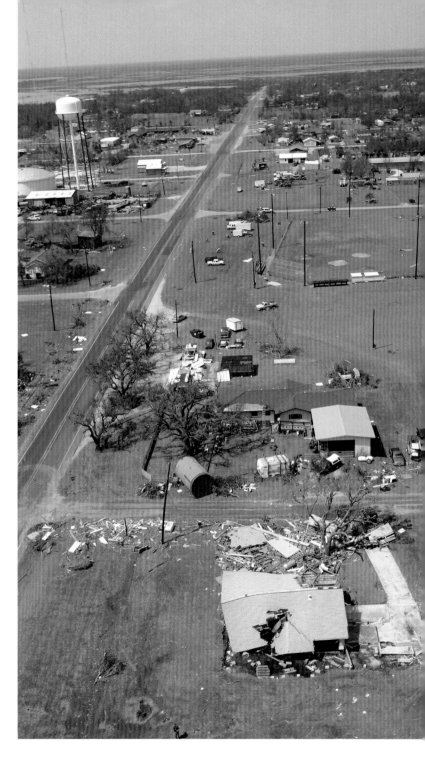

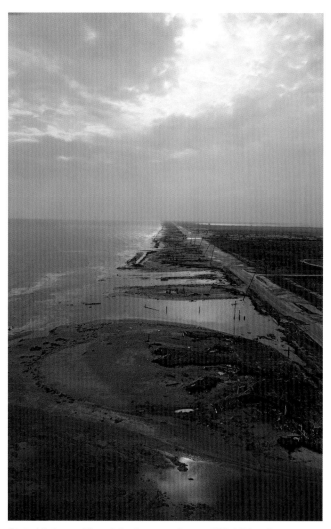

State Highway 87 and the intersection at Oilfield Road near SH 124.

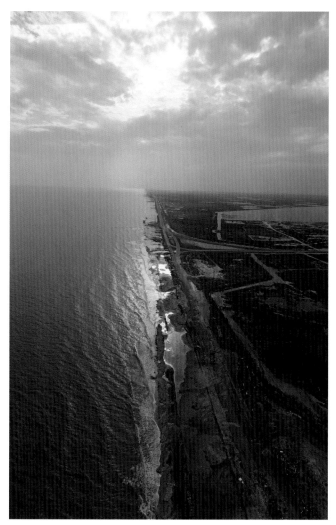

State Highway 87 and the intersection at SH 124, which leads to High Island in eastern Chambers County.

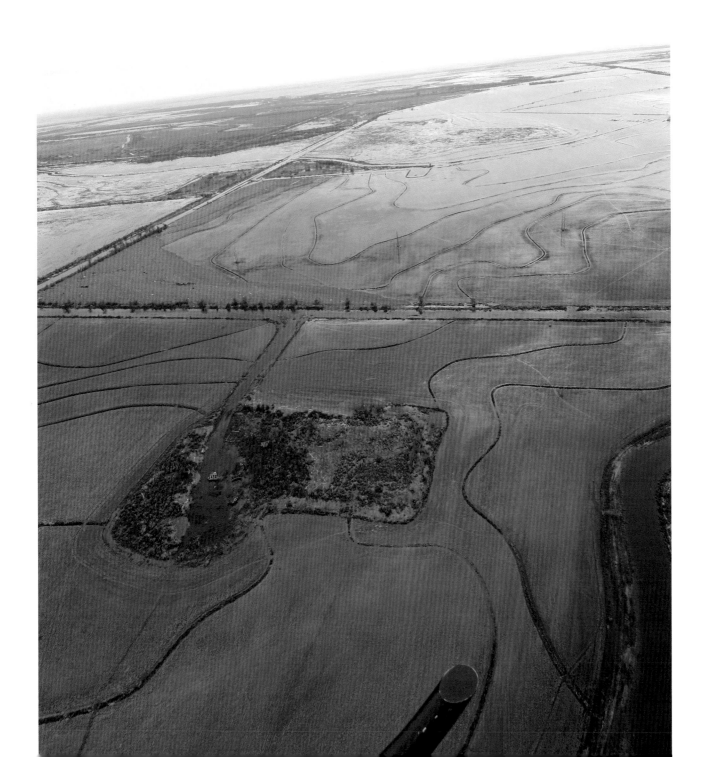

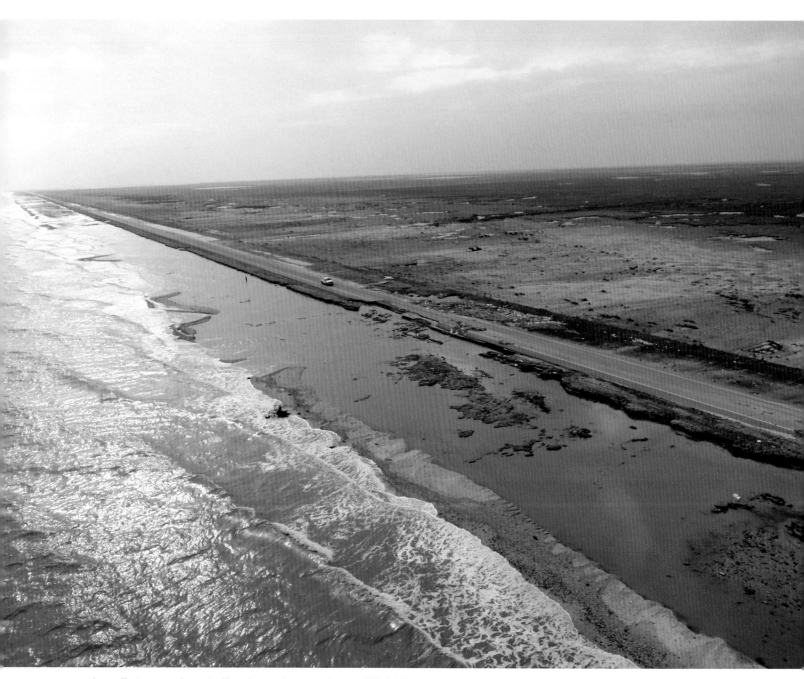

Lone first responder patrolling the roadway northeast of High Island.

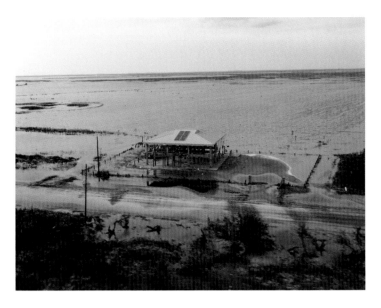

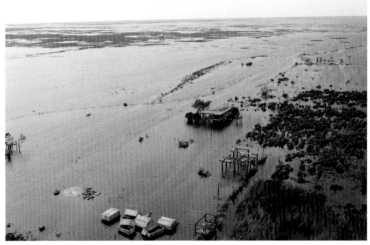

Jefferson County.

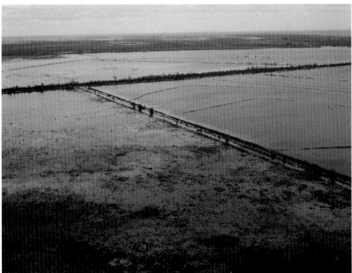

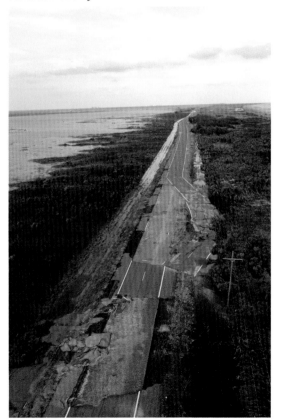

State Highway 87, Jefferson County.

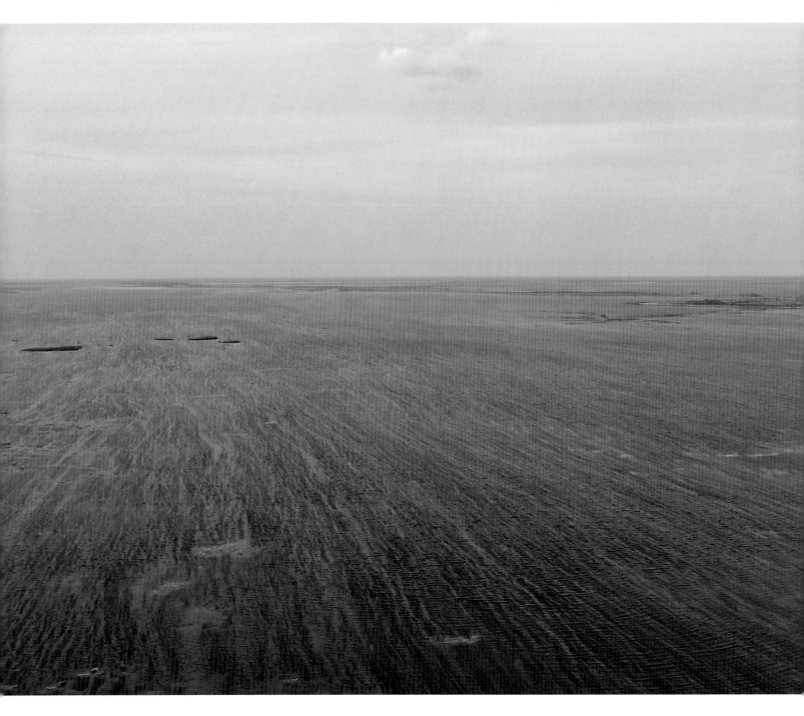

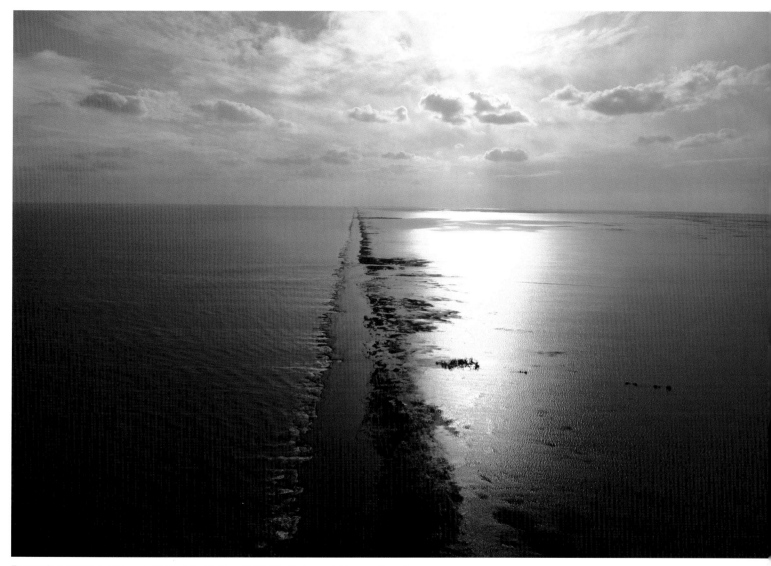

Retreating storm surge over McFaddin National Wildlife Refuge, Jefferson County.

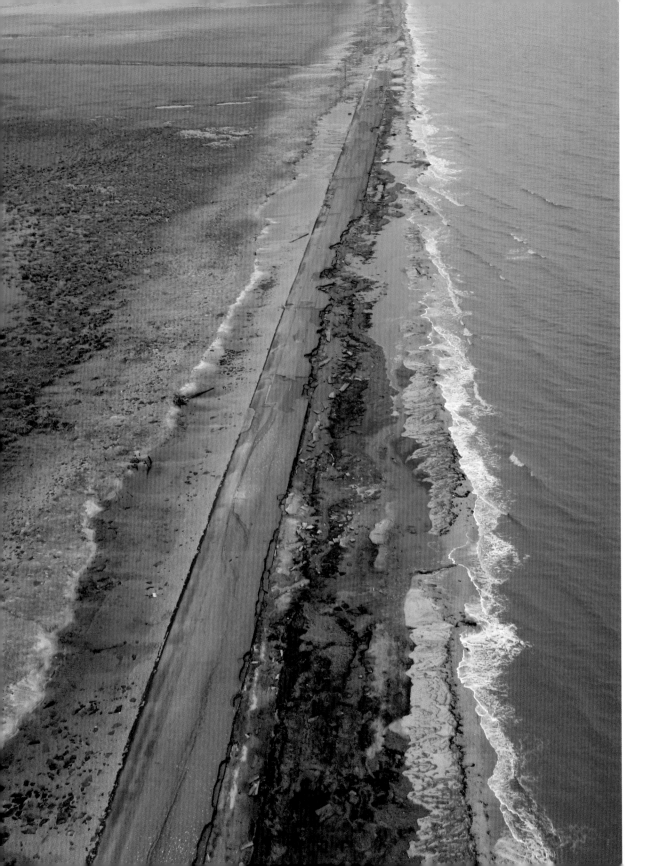

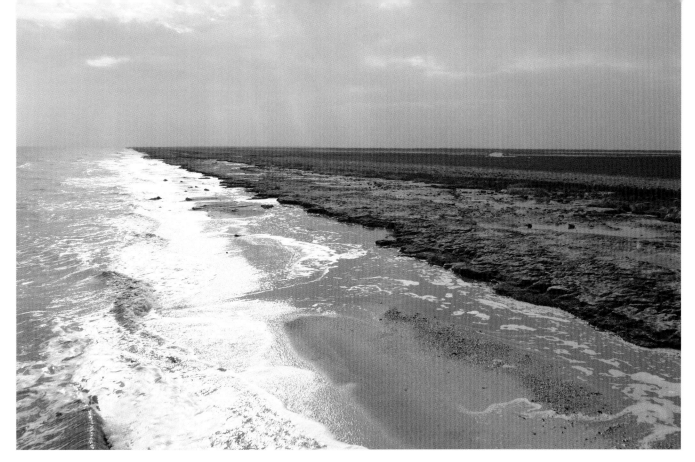

Jefferson County shoreline.

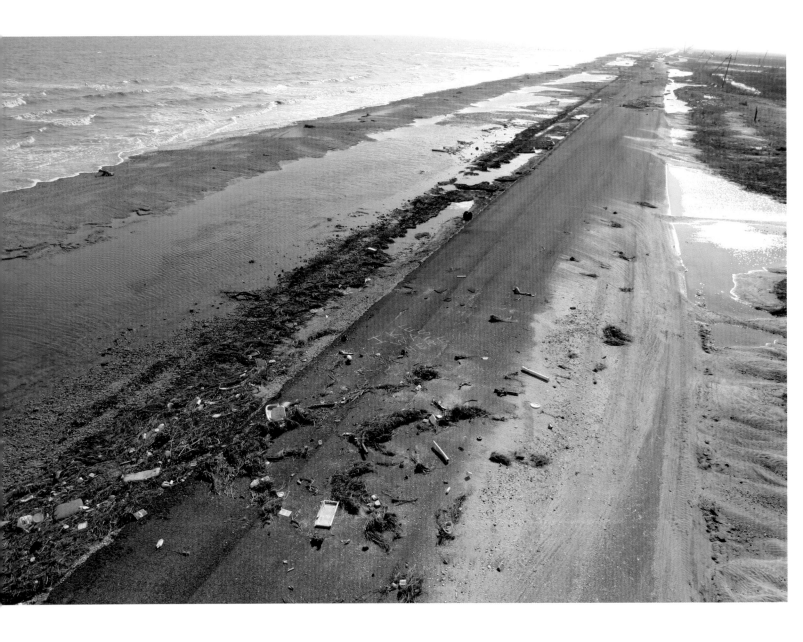

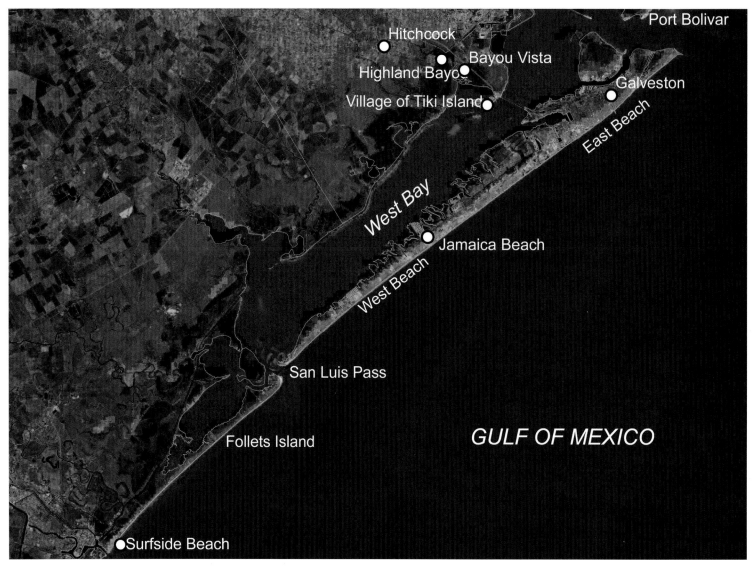

Galveston received a direct hit from Ike at approximately 2:10 a.m CDT, September 13, 2008, as a Category 2 hurricane, bringing sustained winds of 110 mph and a twenty-foot storm surge that swept through Galveston Island. Flooding, loss of power, and lack of plumbing, clean water, and food created unlivable conditions for weeks following the storm. *Satellite image, Landsat 7. Photo NASA/USGS.*

PART 2

Galveston Island
& Brazoria County

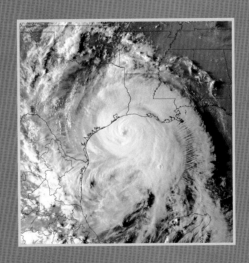

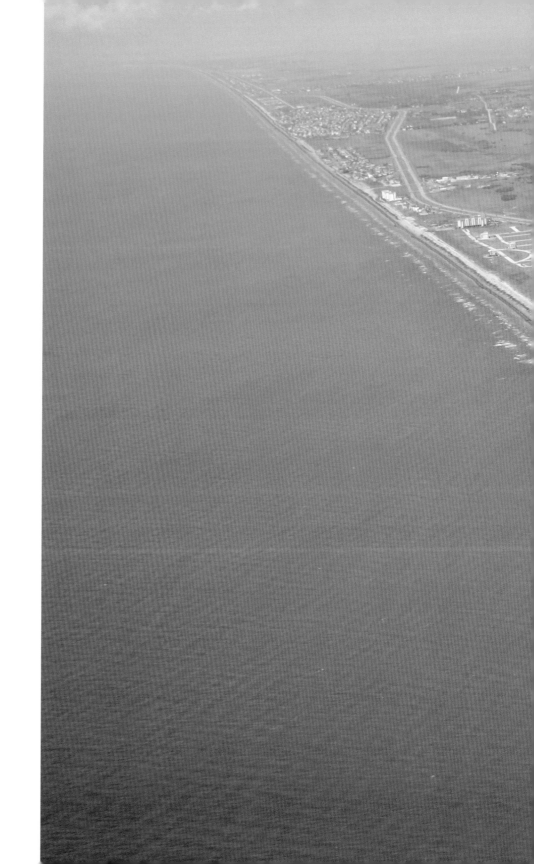

Aerial photograph of the Galveston coastline looking south from the end of the seawall, taken July 2005, when much of the island was experiencing a real estate development "boom."

62

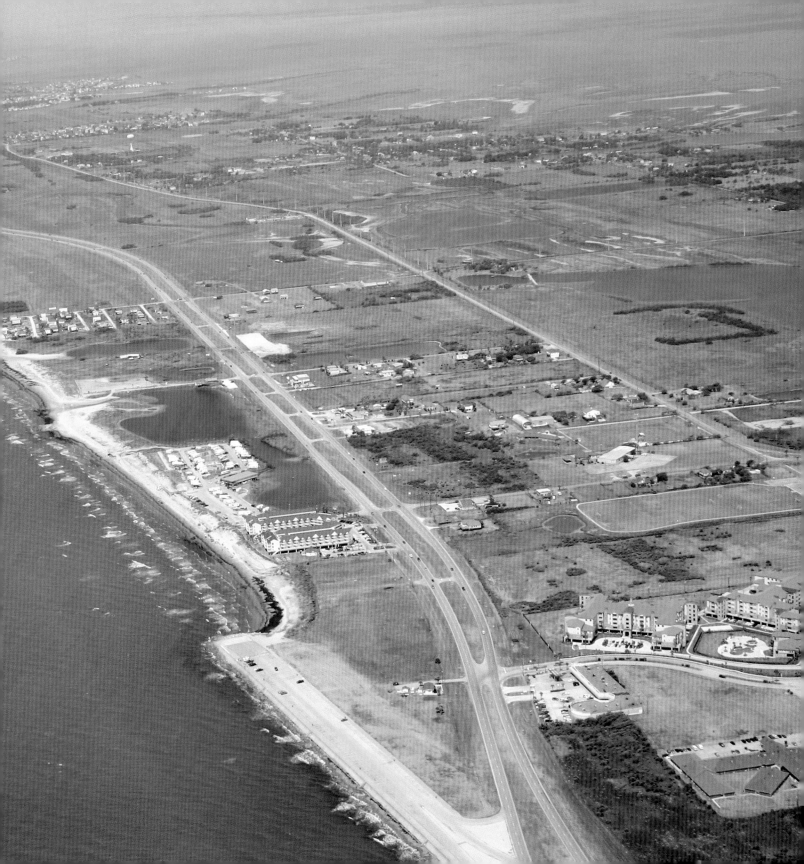

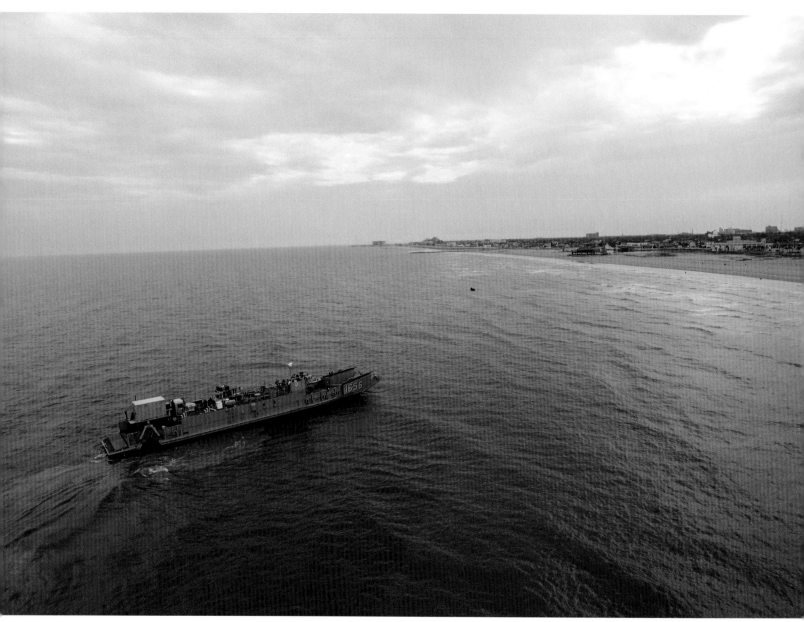

A landing craft from the USS *Nassau* comes ashore with heavy equipment and personnel in disaster response efforts following the landfall of Hurricane Ike. The USS *Nassau* anchored off the Galveston coast a few days after the storm.

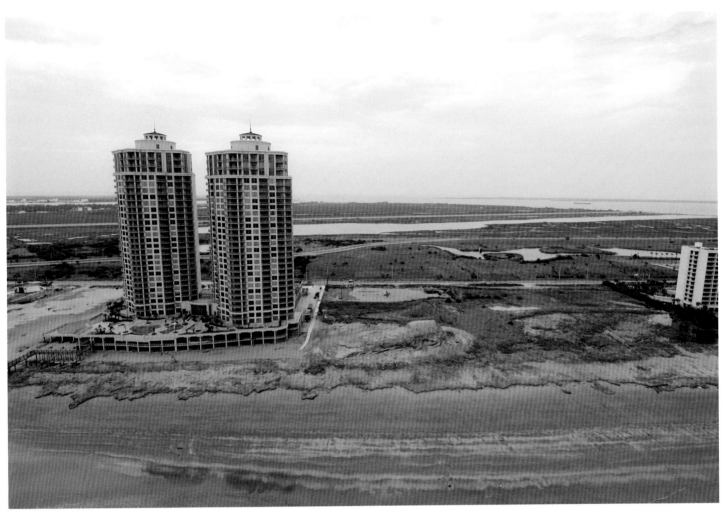

Palisade Palms, a twenty-seven story, twin-tower, high-rise condominium resort near Galveston's East Beach, after Ike.

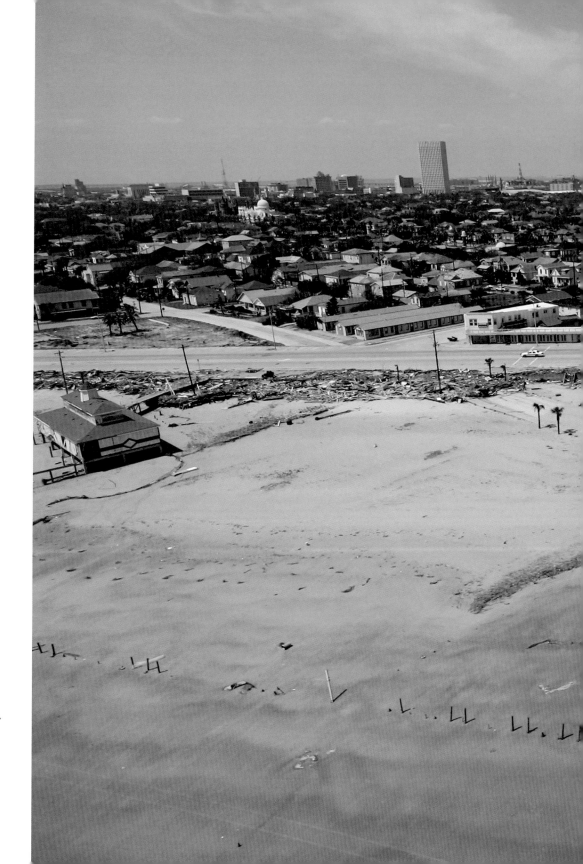

Seawall Boulevard and
Seventh Street, East Beach.

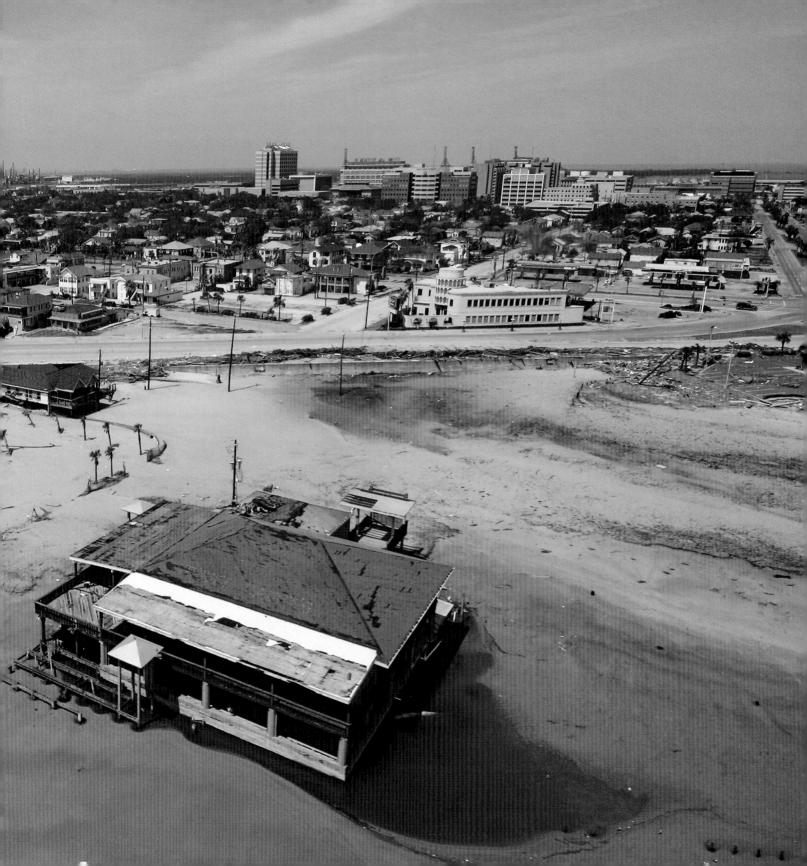

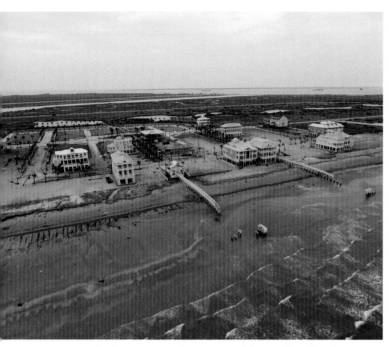

Newly constructed homes surviving on East Beach.

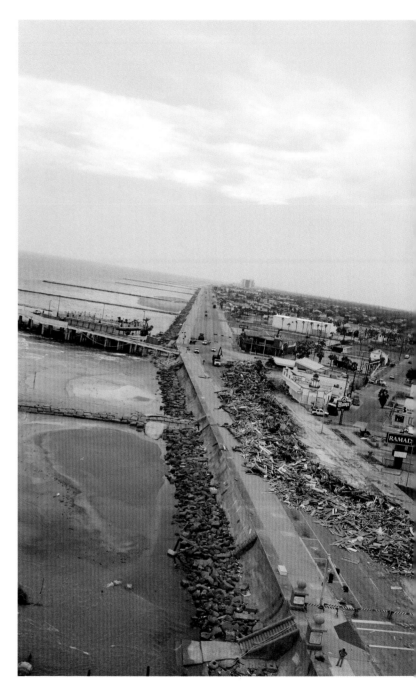

Debris on Seawall Boulevard.

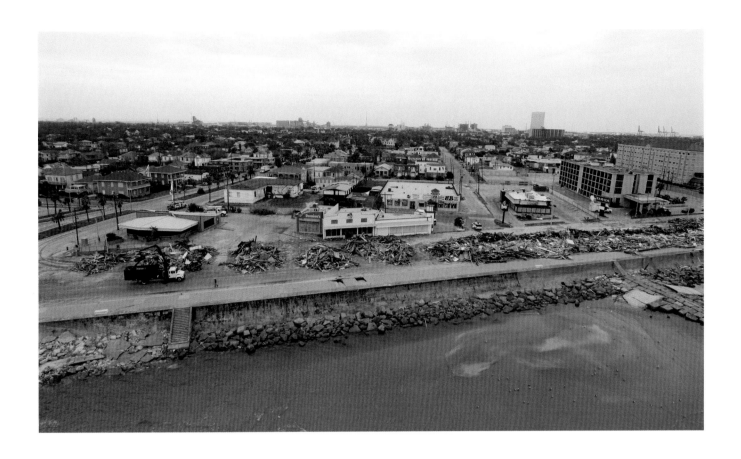

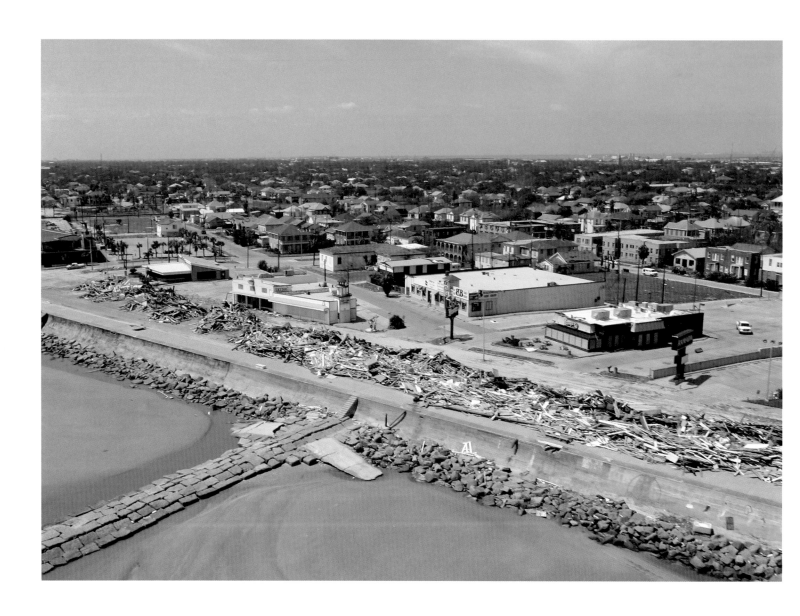

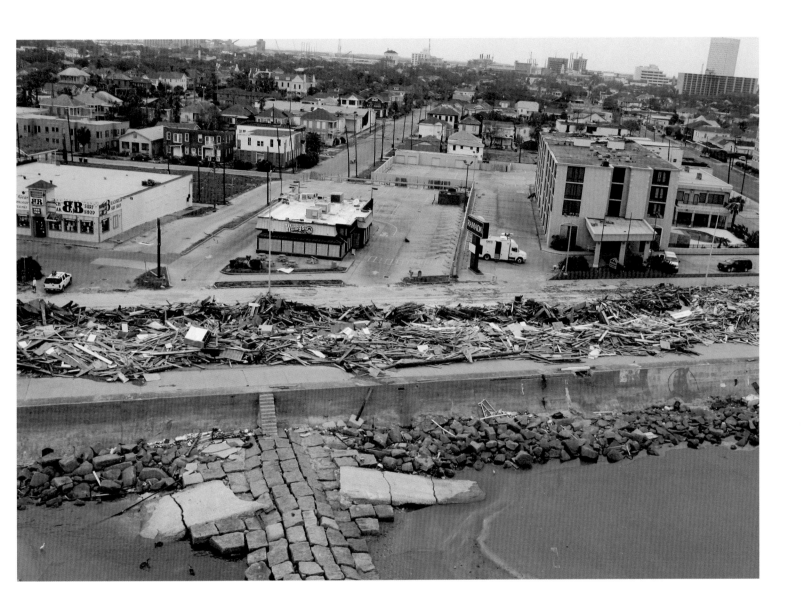

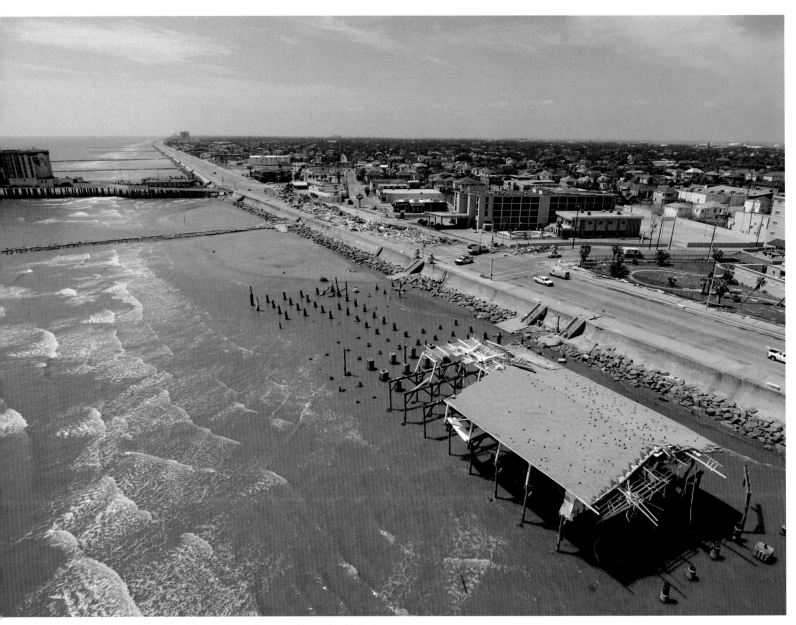

Former location of a restaurant and the remains of the historic
Murdoch's Bathhouse, a destination for tourists and locals
since 1910.

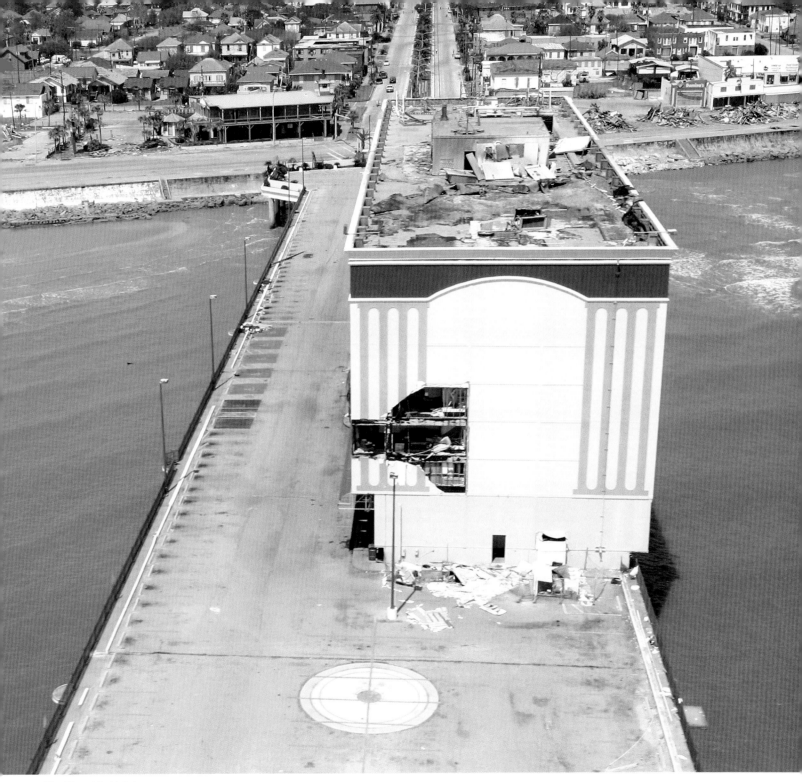

The Flagship Hotel.

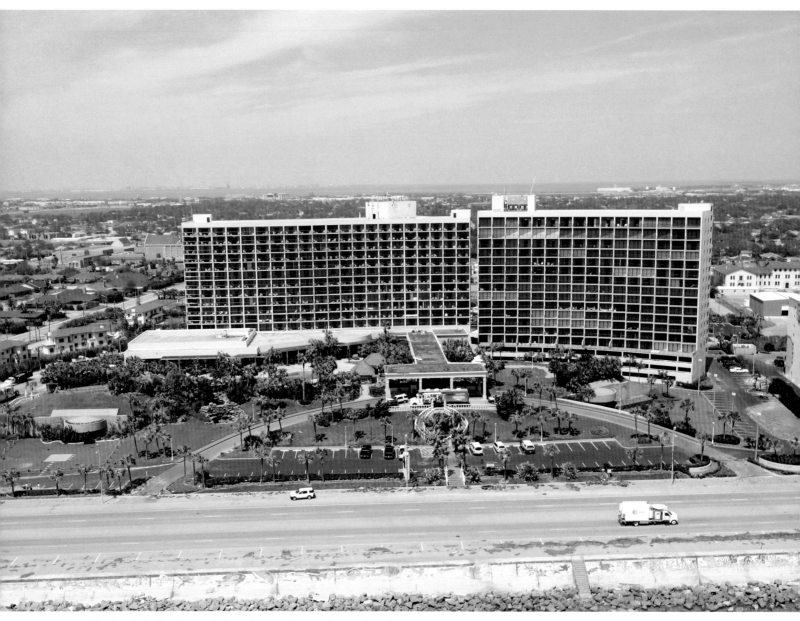

The San Luis Hotel provided a refuge and base of operations for news media during and after Hurricane Ike.

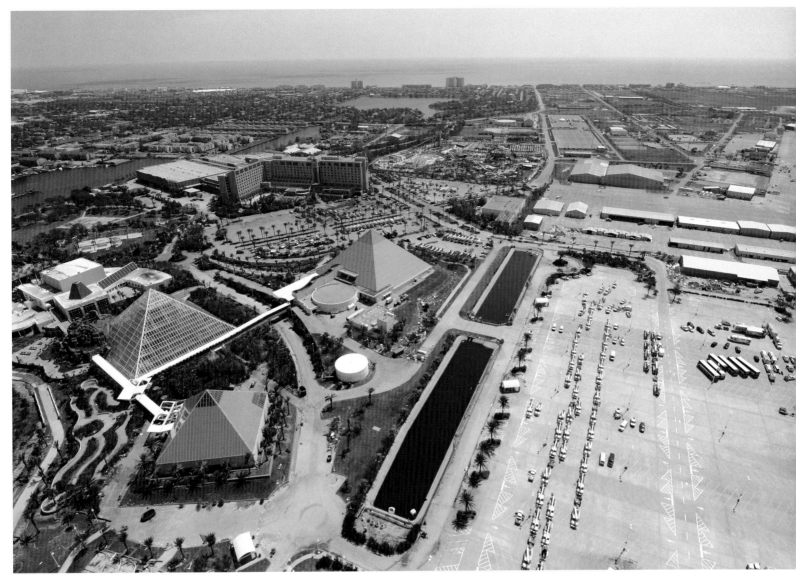

Moody Gardens park and resort, including a staging area where utility vehicles prepared to repair much of the island's electrical infrastructure. Crews came from many parts of the U.S. to assist in the effort.

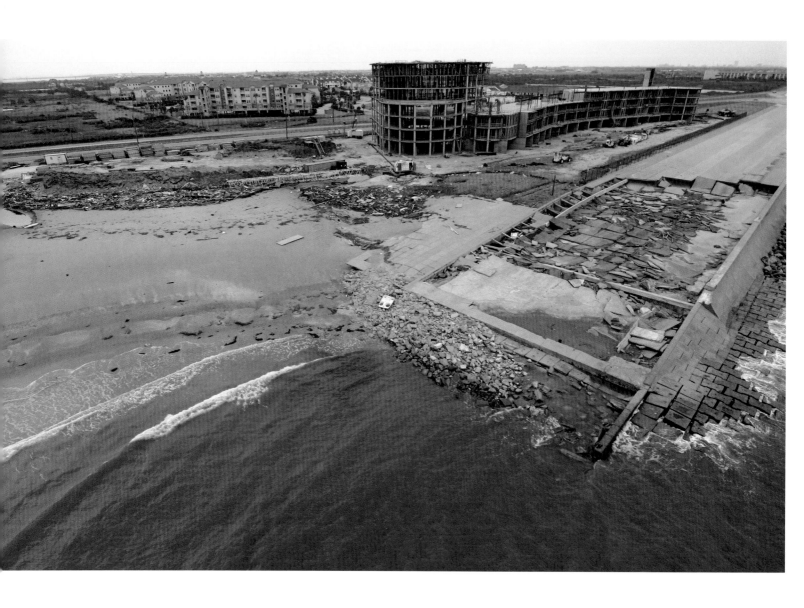

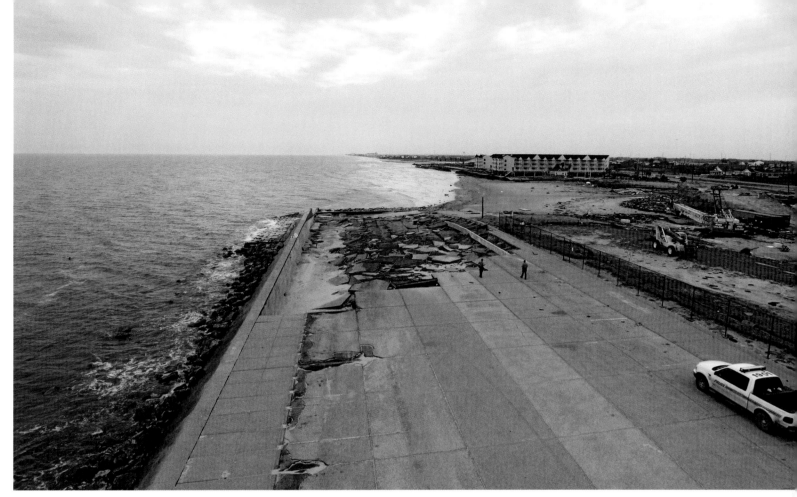

The west end of the Galveston Seawall.

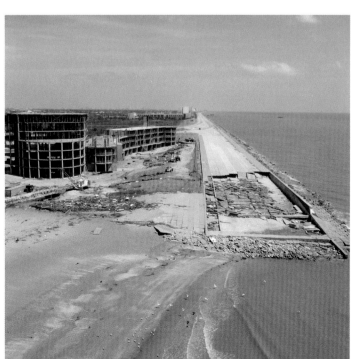

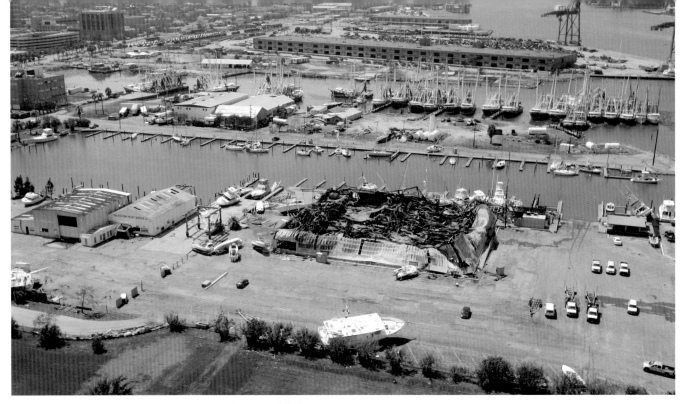

Burned structure near Barracuda Avenue by the Port of Galveston.

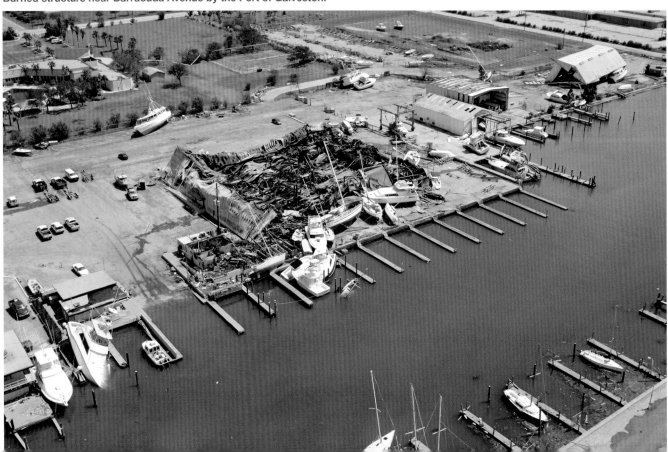

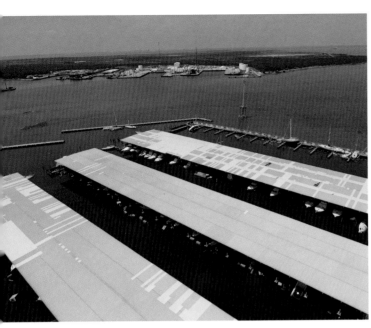

Galveston marina.

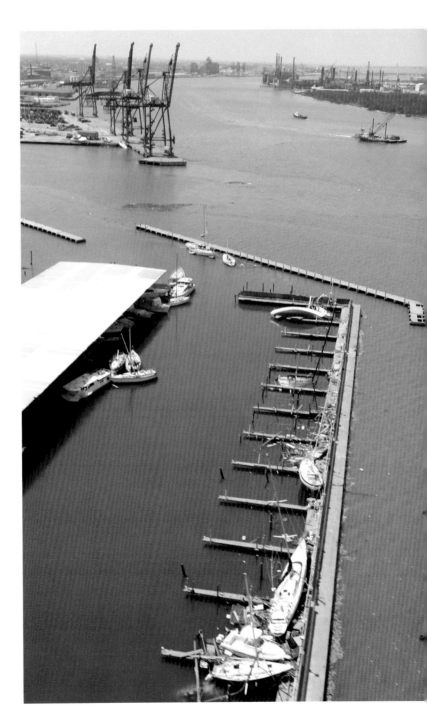

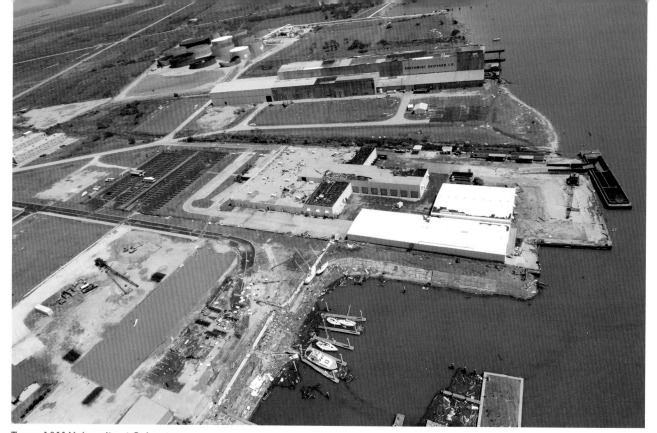

Texas A&M University at Galveston.

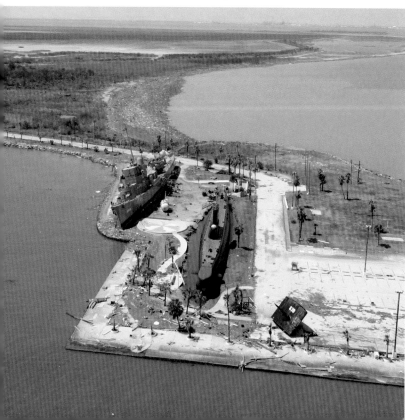

Seawolf Park, Galveston.

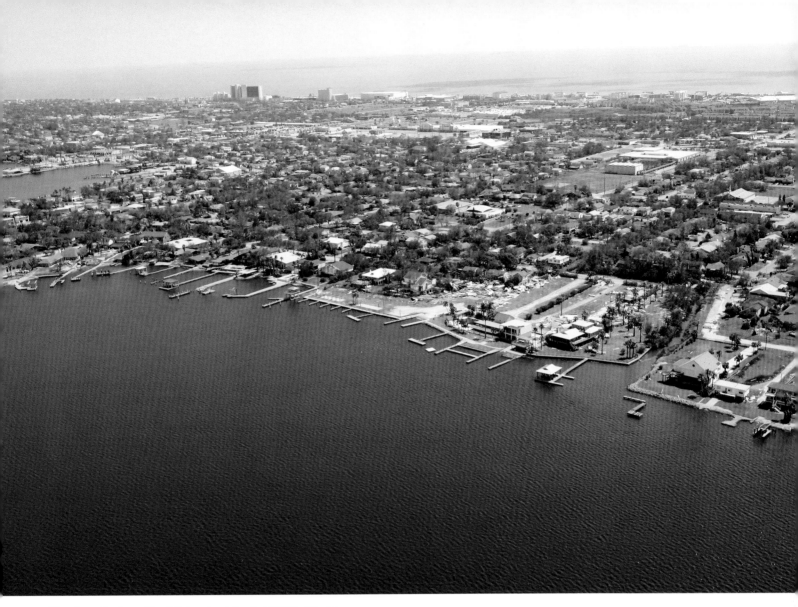

View from the bay side of Galveston Island at Offatts Bayou,
looking toward the Gulf of Mexico.

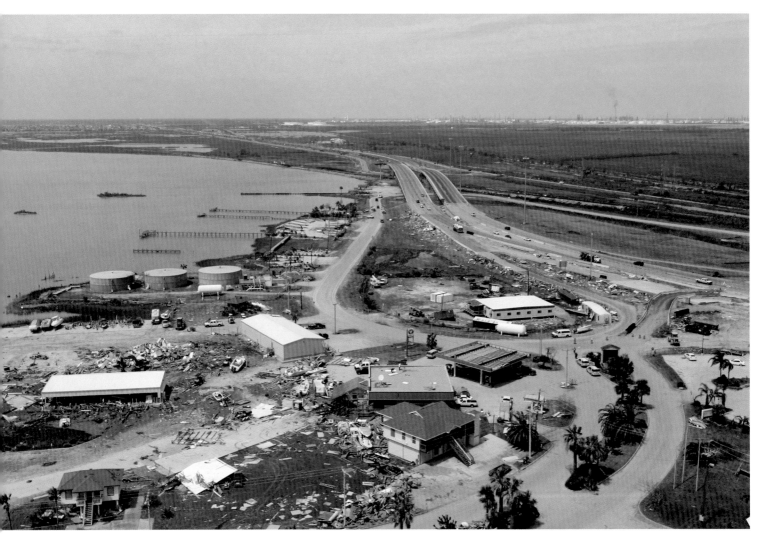

Interstate 45 and Tiki Drive, just north of the
Galveston Causeway.

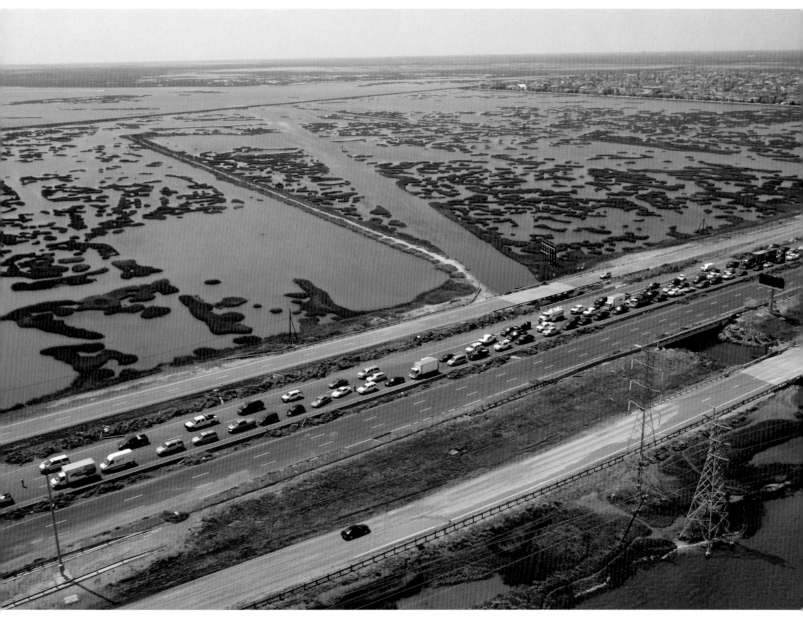

Traffic on I-45 southbound returning to the island. In the days after the storm, first responders were granted limited access while all others were banned from the island until given notice by government officials.

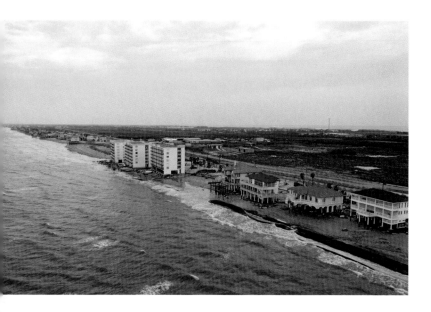
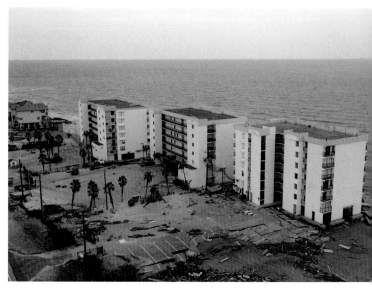
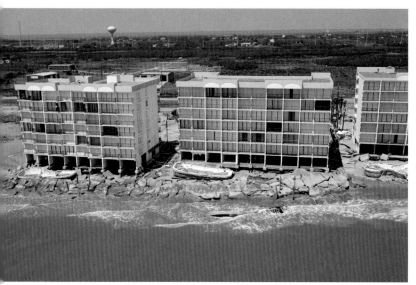
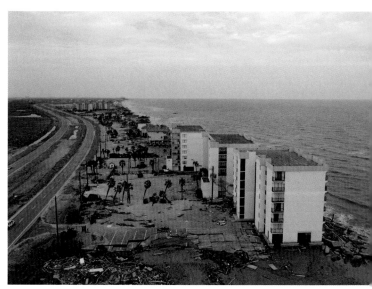

West Beach Grand condominiums off San Luis Pass Road, two miles west of the Galveston Seawall.

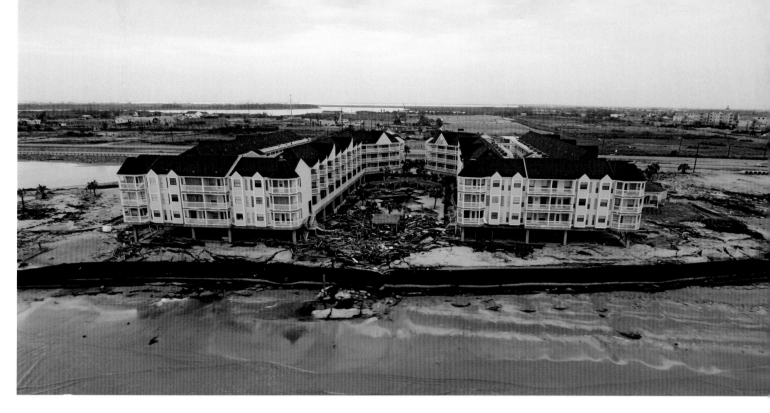

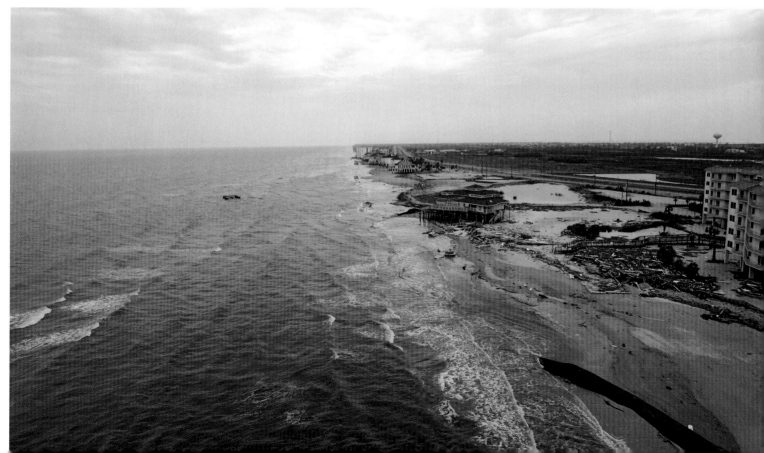

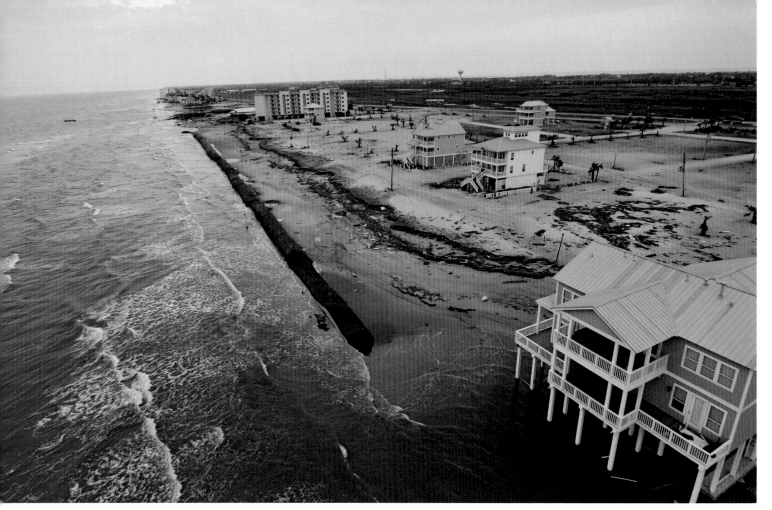

Exposed geotextile tubes (geotubes) were evident all along the Galveston shoreline. Geotubes are elliptical textile bags filled with sand and slurry that is pumped into the tubes to form a firm unit. Much of the Texas shoreline is protected by geotubes buried under the sand in an effort to reduce beach erosion seaward.

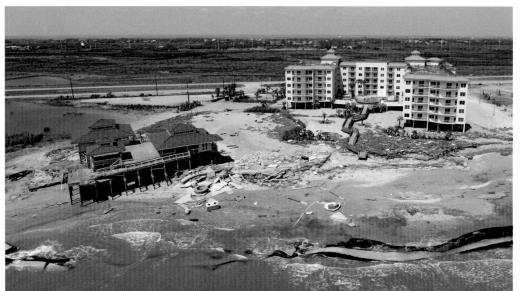

The Escapes! condominium resort, constructed in 2005 on Galveston's west end.

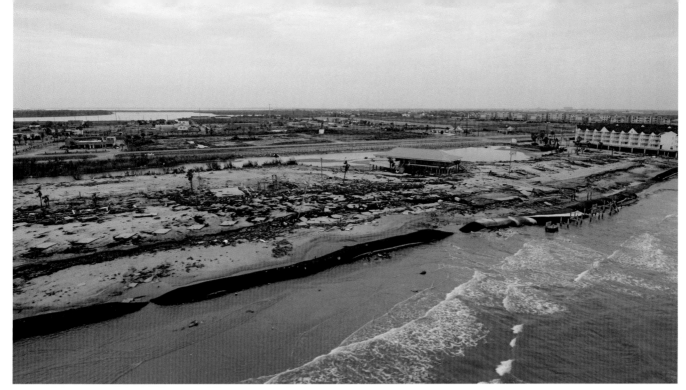

Sand Castle Beach (Frank Carmona Pocket Park 2), west end of
Galveston Island.

Bay Harbor subdivision, West Beach at First Street and
San Luis Pass Road.

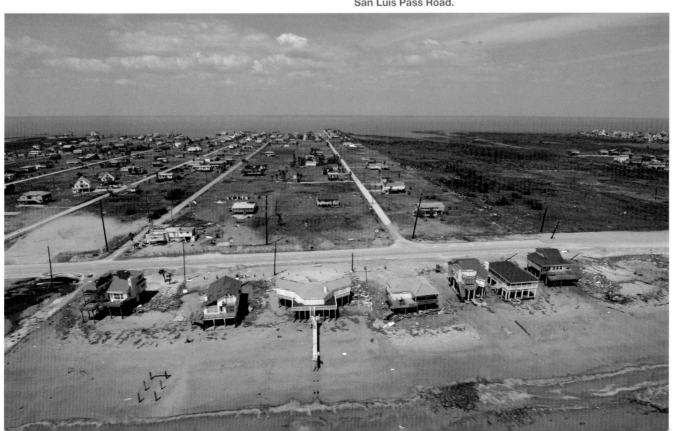

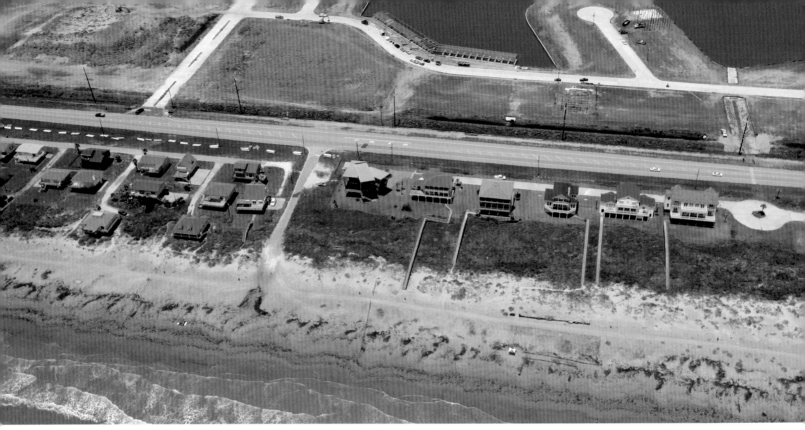

Beach homes photographed in July 2007, before Hurricane Ike, at Gulf
Drive and Termini-San Luis Pass Road just west of the seawall.

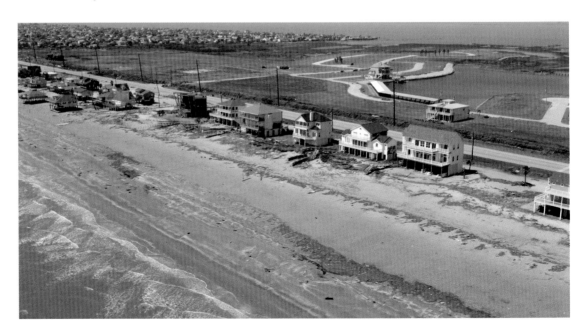

Homes and
shoreline after Ike.

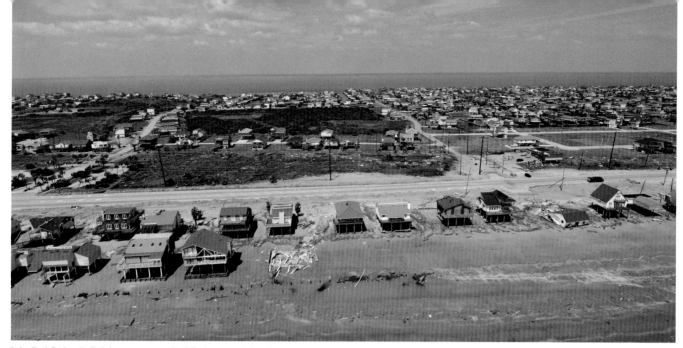

Isla Del Sol subdivision, west end of Galveston Island.

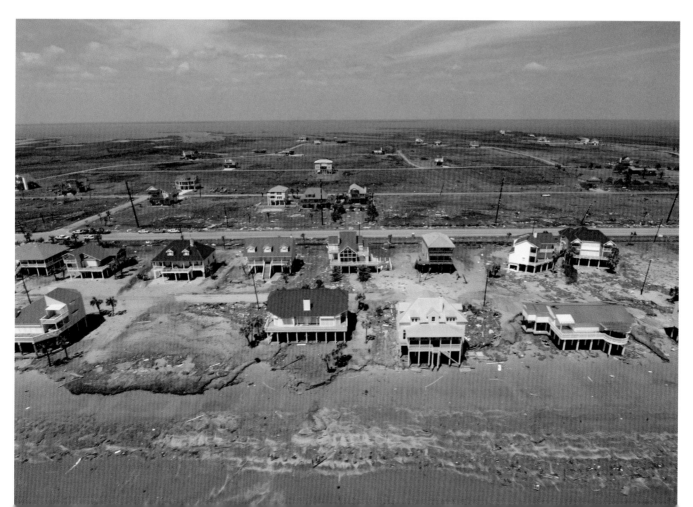

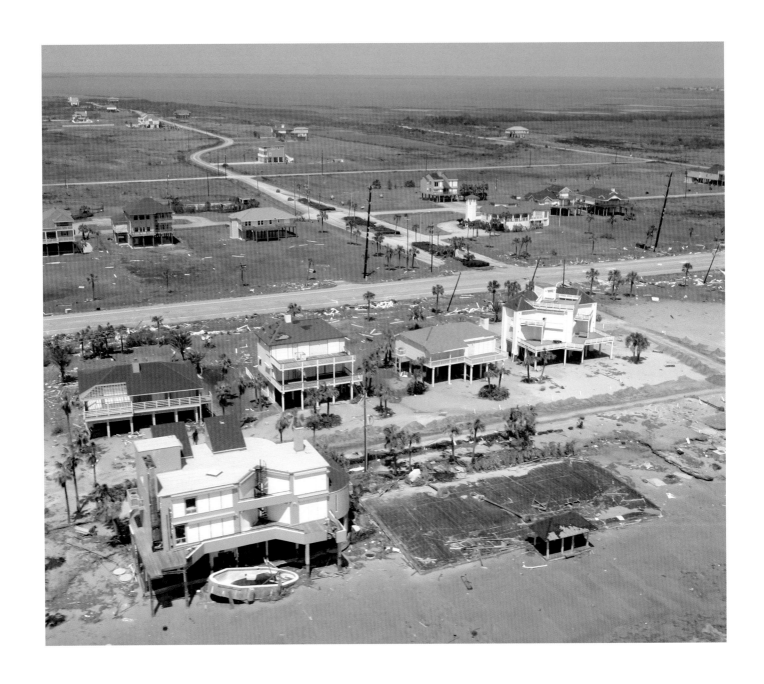

Right: Mobile home park, west end of Galveston Island, southwest of Jamaica Beach.

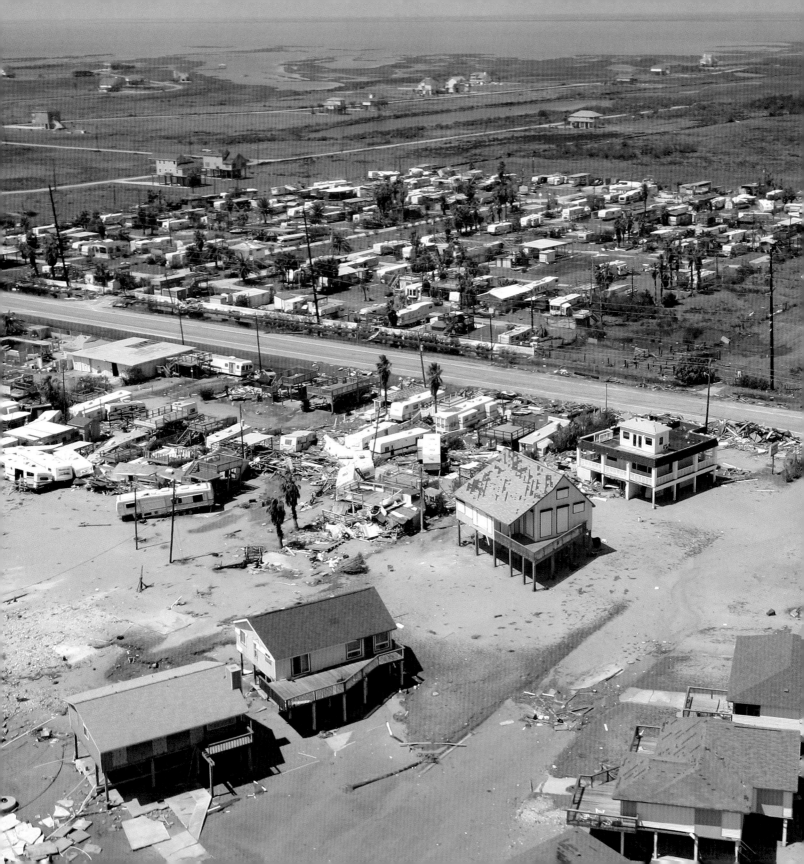

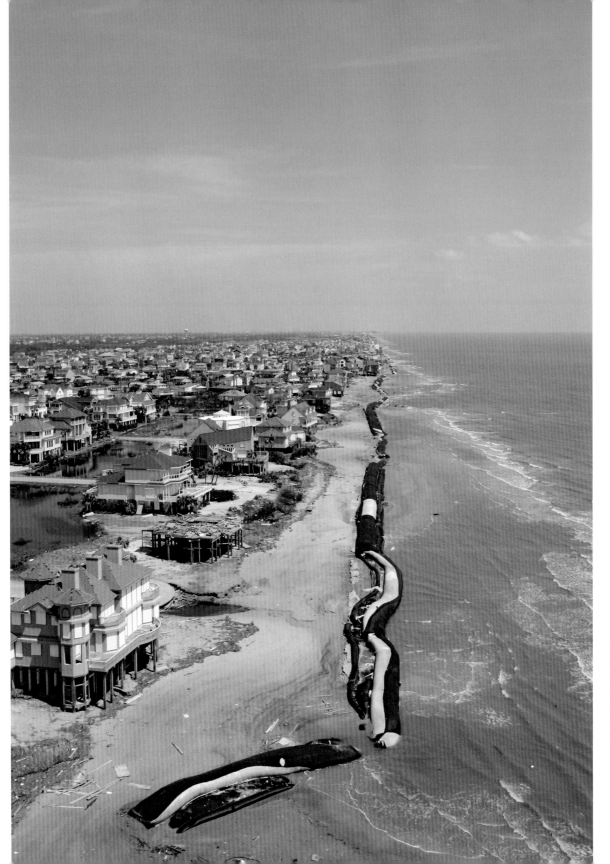

Looking northeast near Pirates' Beach subdivision and Galveston Island State Park; exposed geotubes along the Galveston coastline.

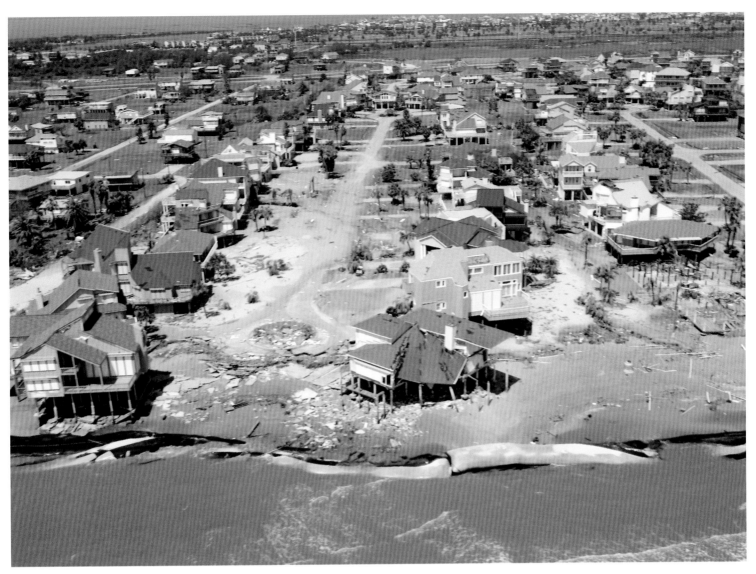

West Beach.

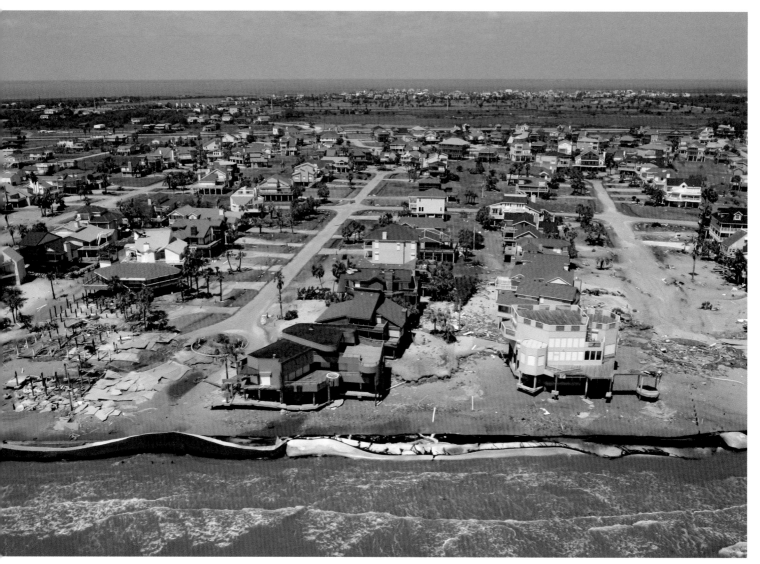

West Beach.

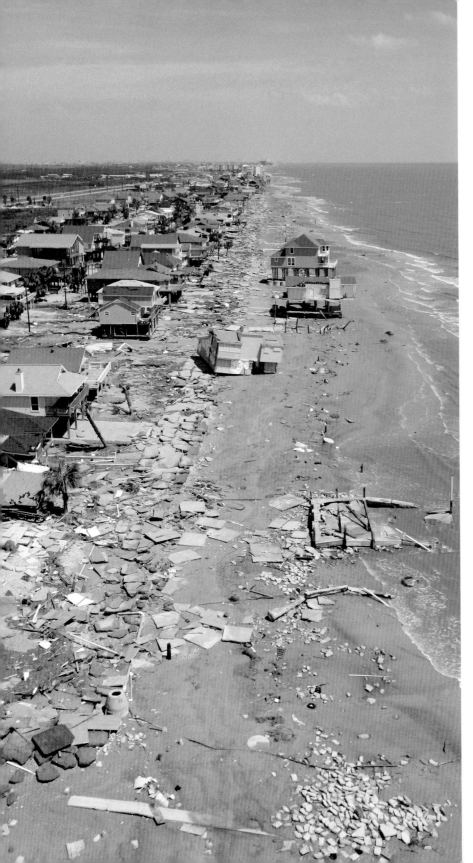

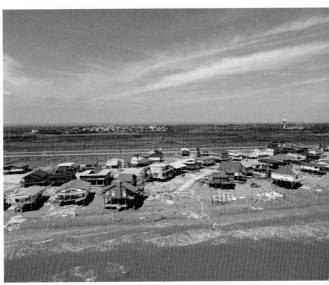

West Beach.

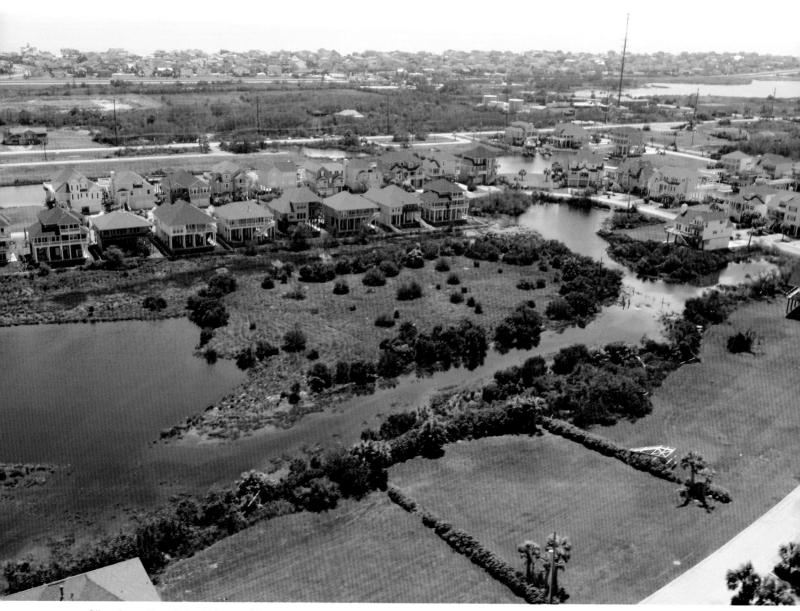

Oil and gasoline slick within a residential neighborhood.

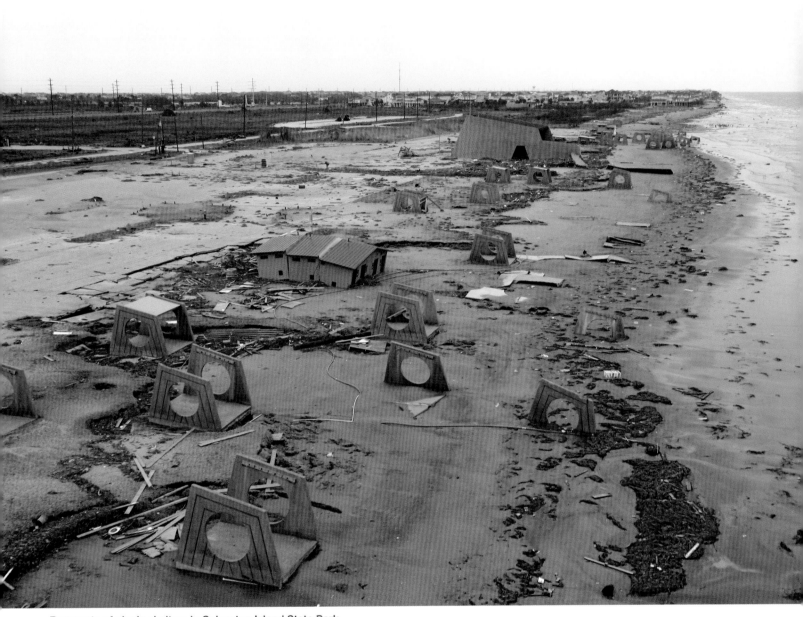

Remnants of picnic shelters in Galveston Island State Park.

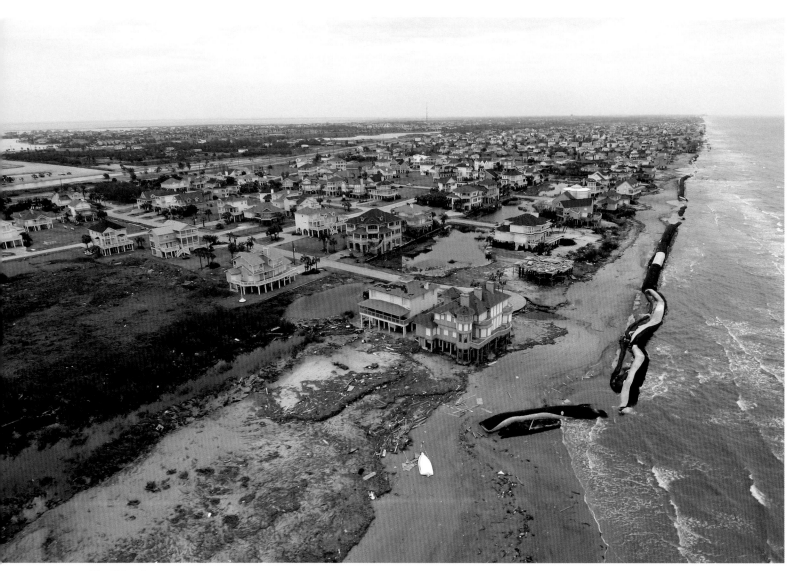

West Beach.

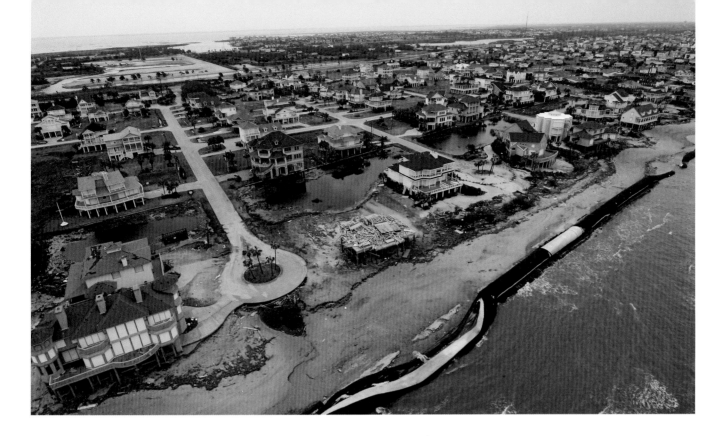

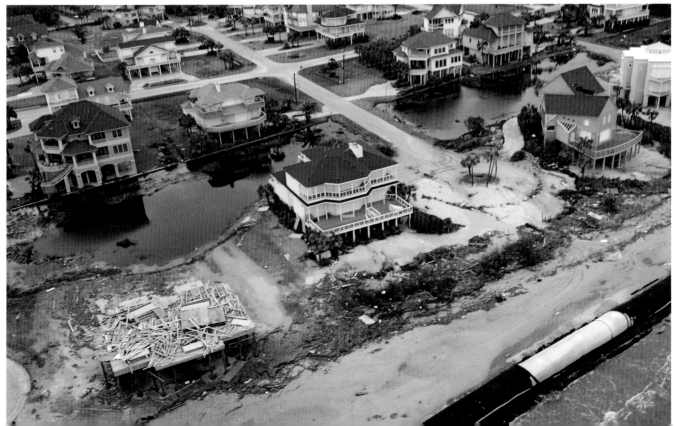

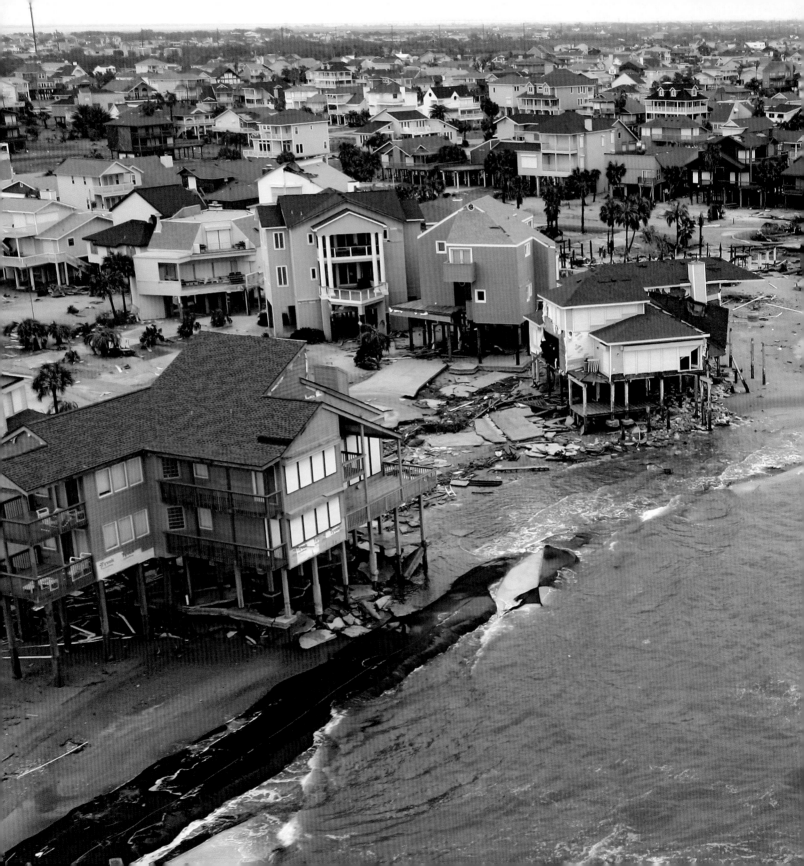

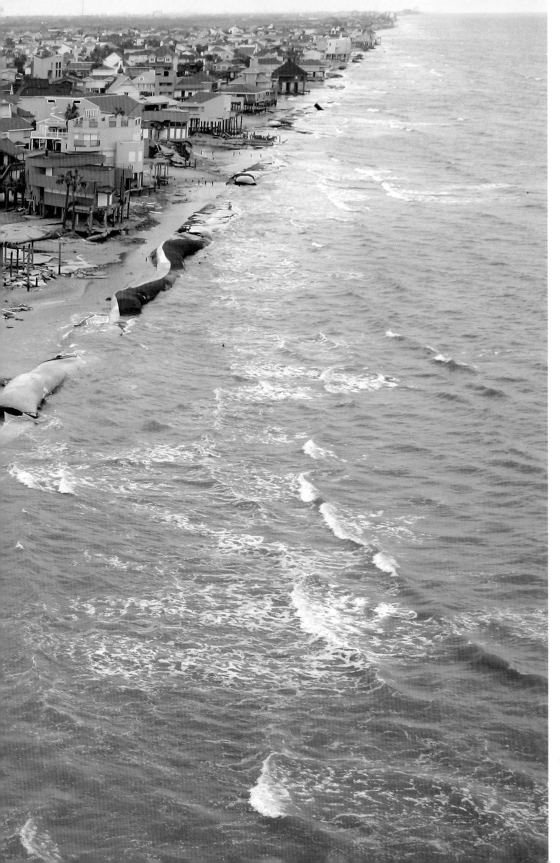

West Beach.

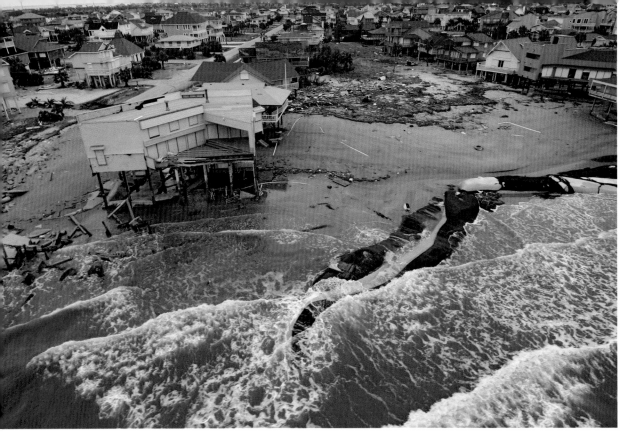

West Beach.

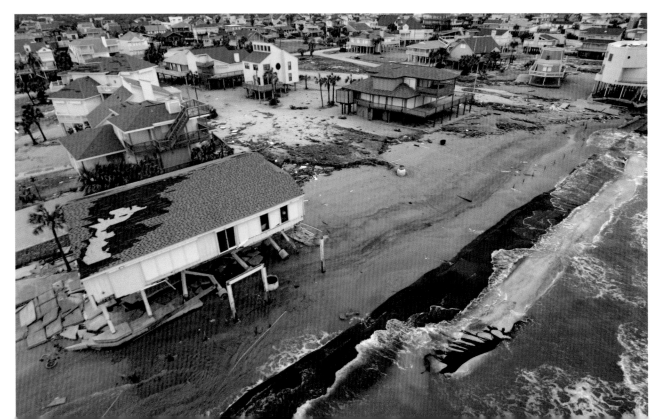

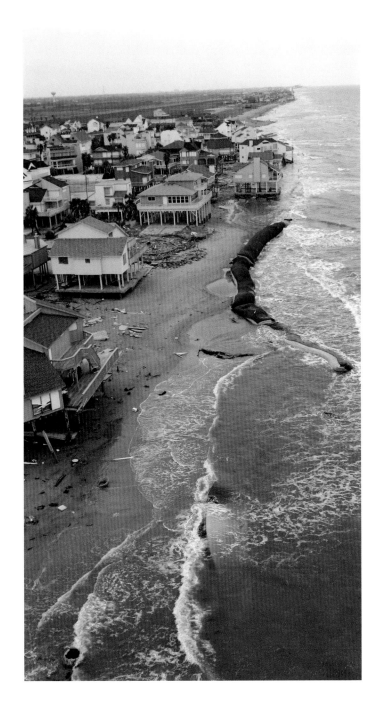
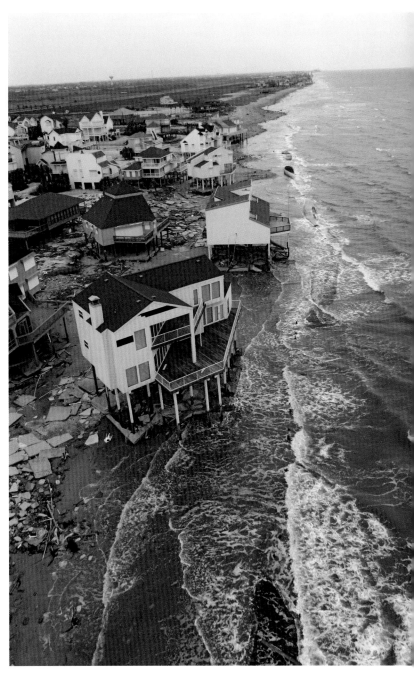

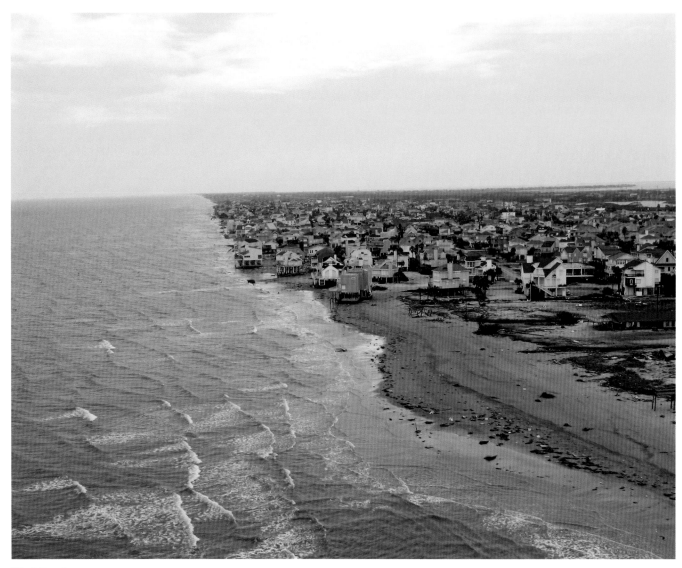

West Beach.

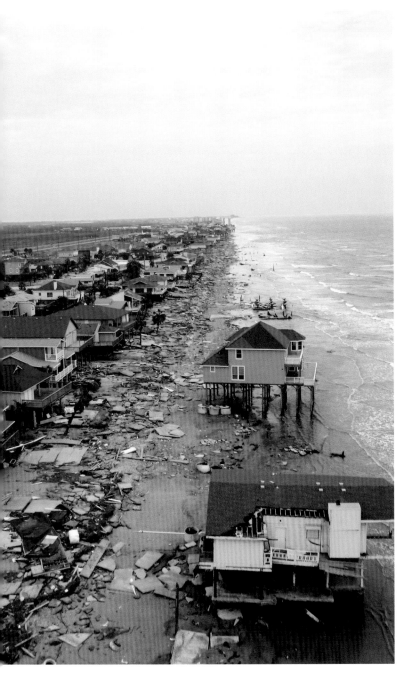

West Beach.

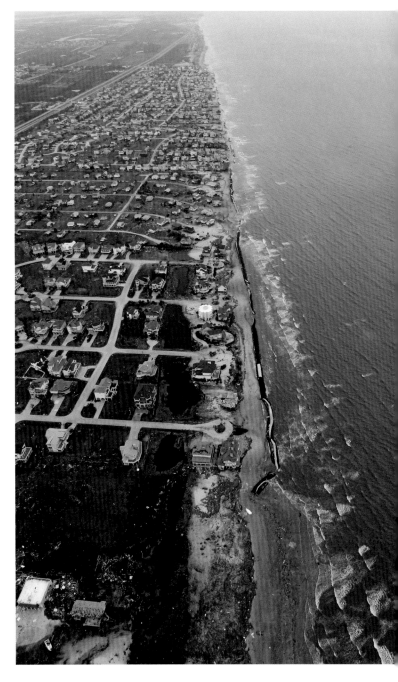

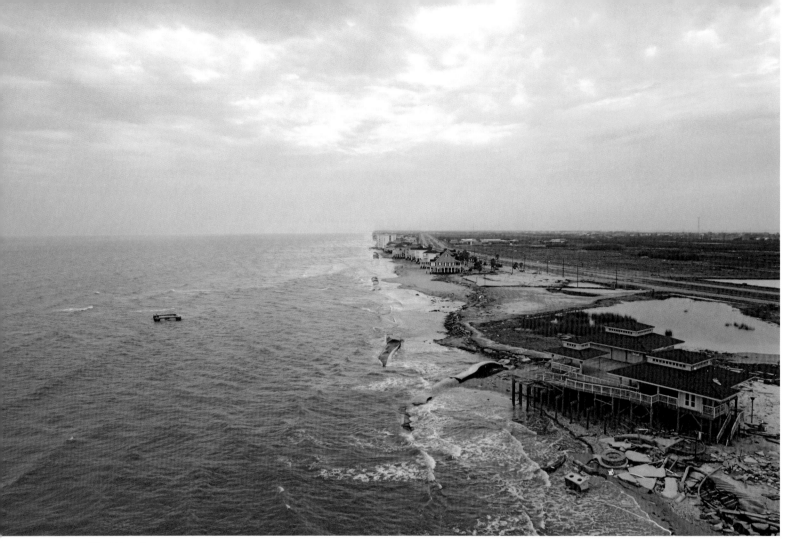

West Beach.

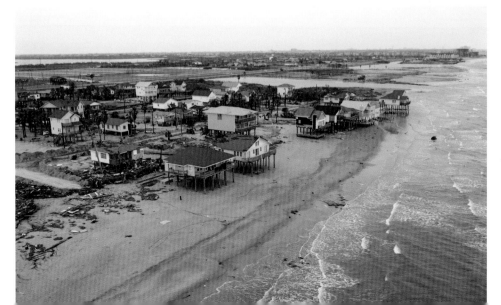

Looking northeast toward the end
of the Galveston Seawall; West
Beach.

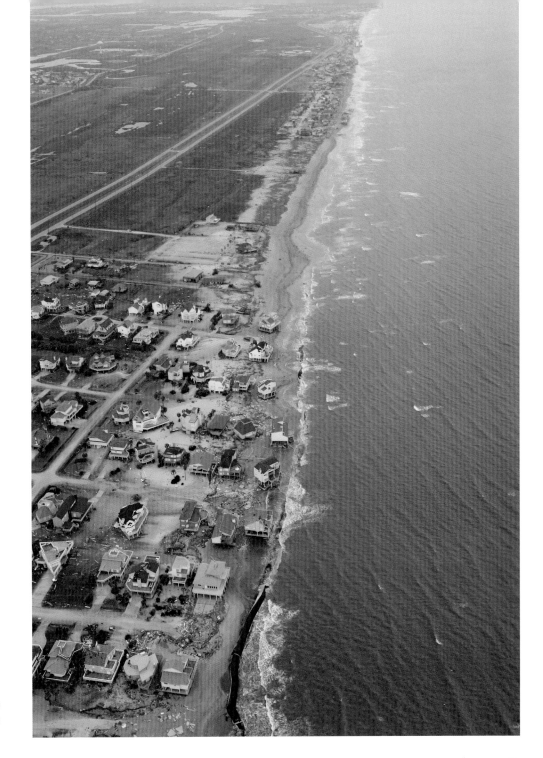

Looking northeast toward the end of the Galveston Seawall; West Beach.

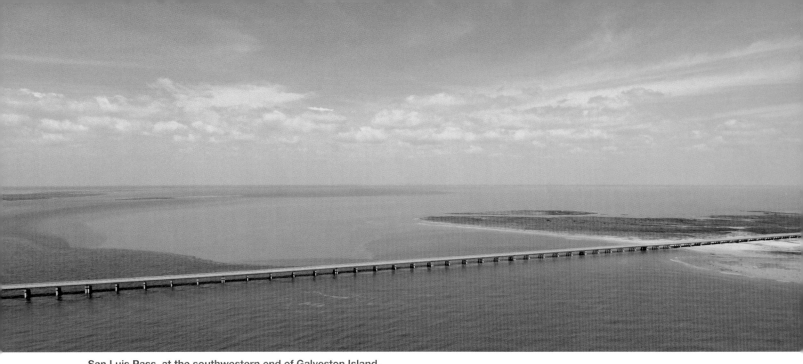

San Luis Pass, at the southwestern end of Galveston Island.

Treasure Island subdivision, Brazoria County.

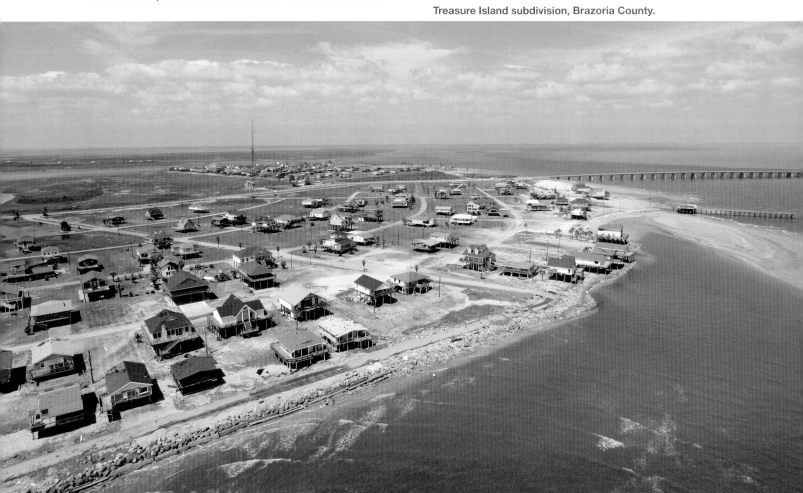

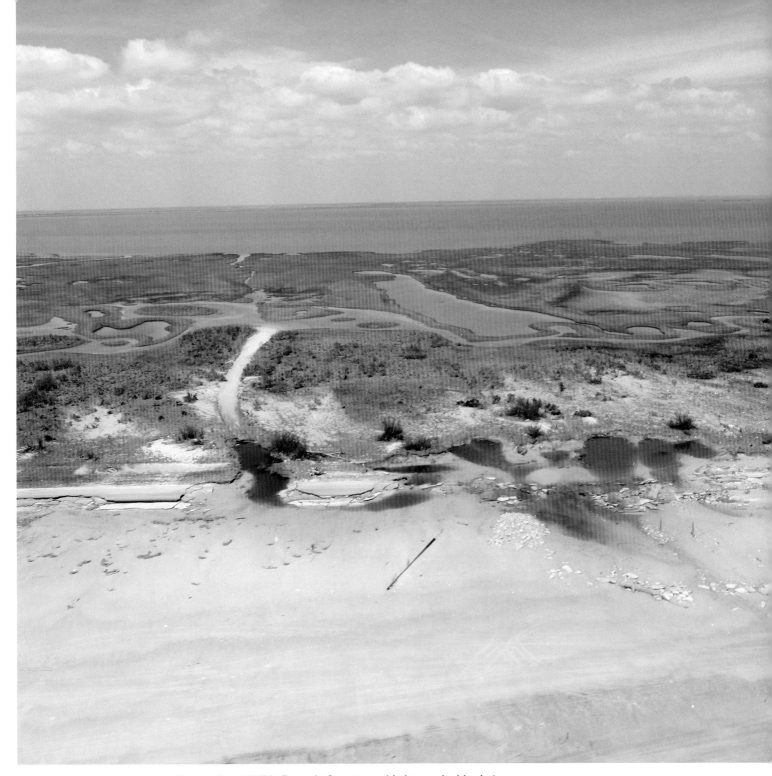

Before Ike, Blue Water Highway (County Road 257) in Brazoria County provided a scenic drive between Galveston and Freeport.

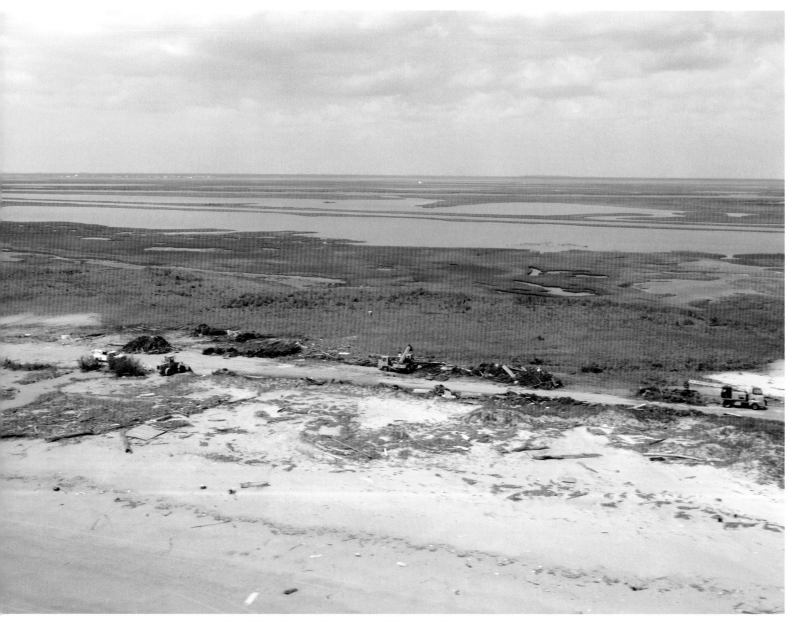

Heavy equipment clearing Blue Water Highway, Follets Island, Brazoria County.

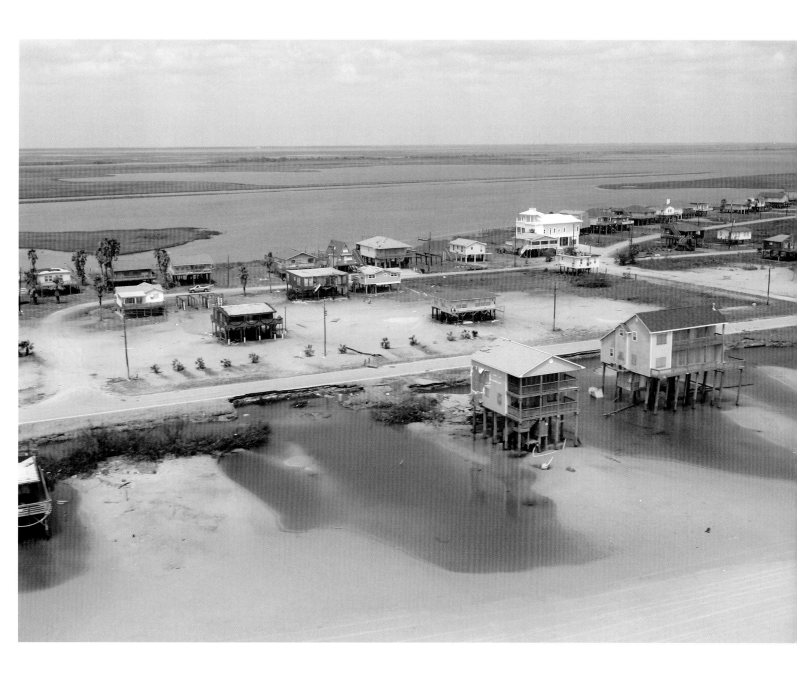

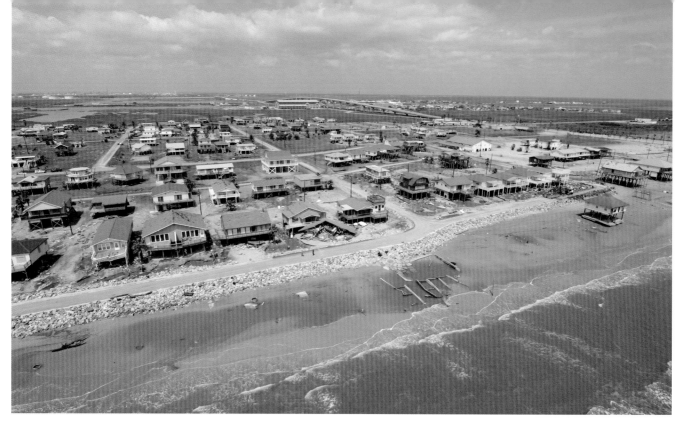

Surfside Beach, Brazoria County.

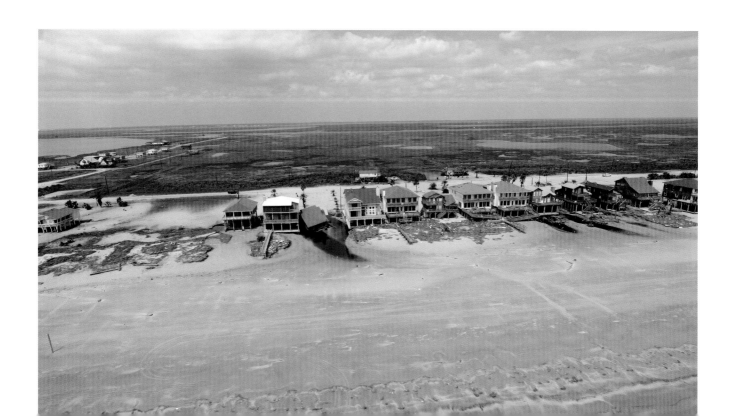

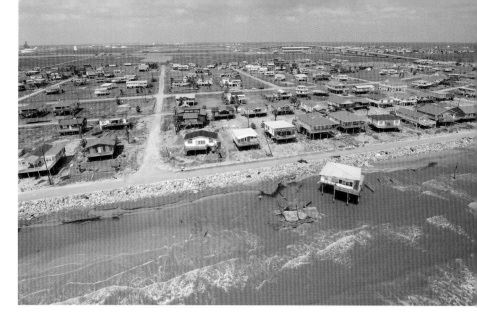

Surfside Beach, Brazoria County.

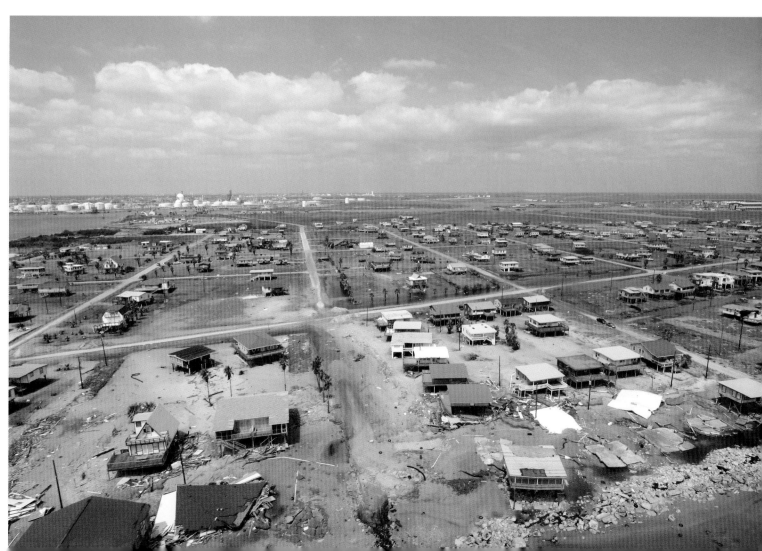

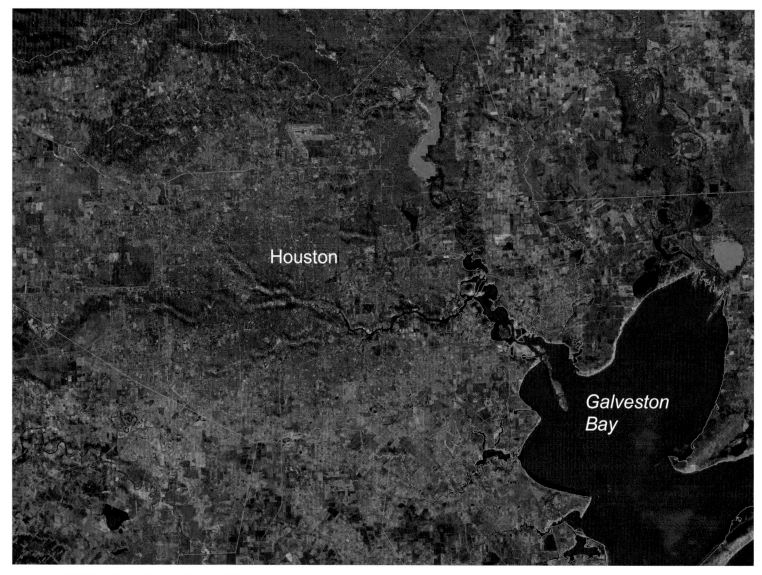

Houston

Galveston Bay

After Ike, residents of Houston and the surrounding areas faced loss of power and water pressure, flooding, broken windows, structural damage, food and water shortages, and hundreds of downed trees. *Satellite image, Landsat 7. Photo NASA/USGS.*

PART 3

Houston & Harris County

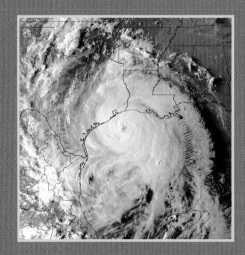

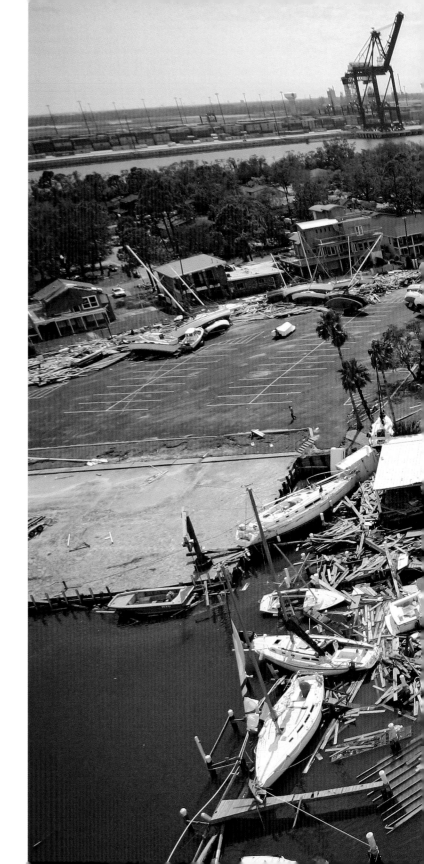

The Houston Yacht Club after Ike, with Bayport shipping terminal in the background.

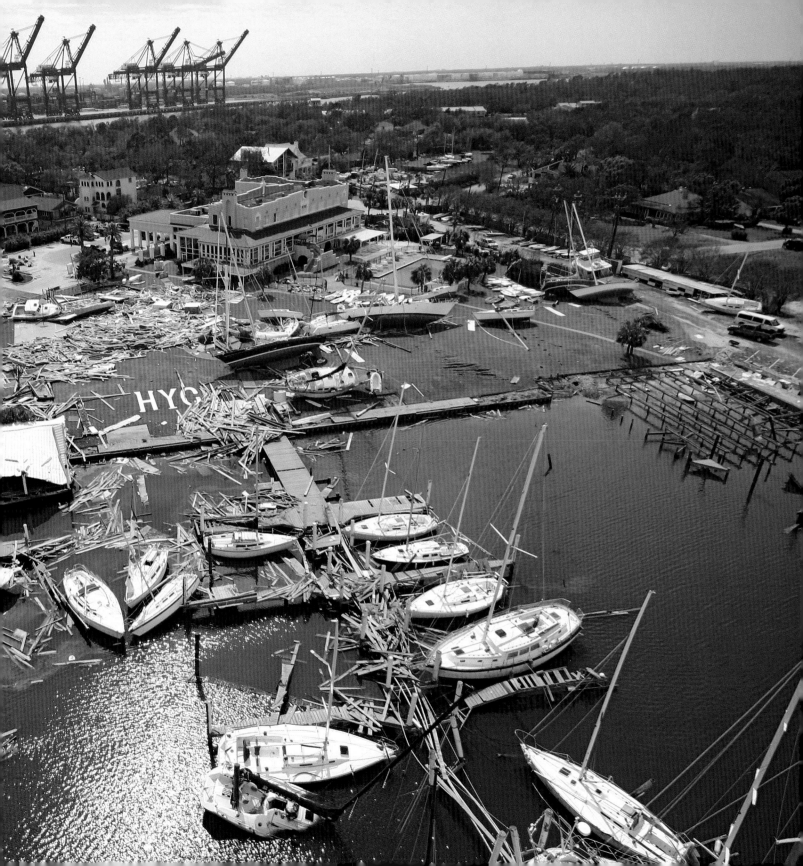

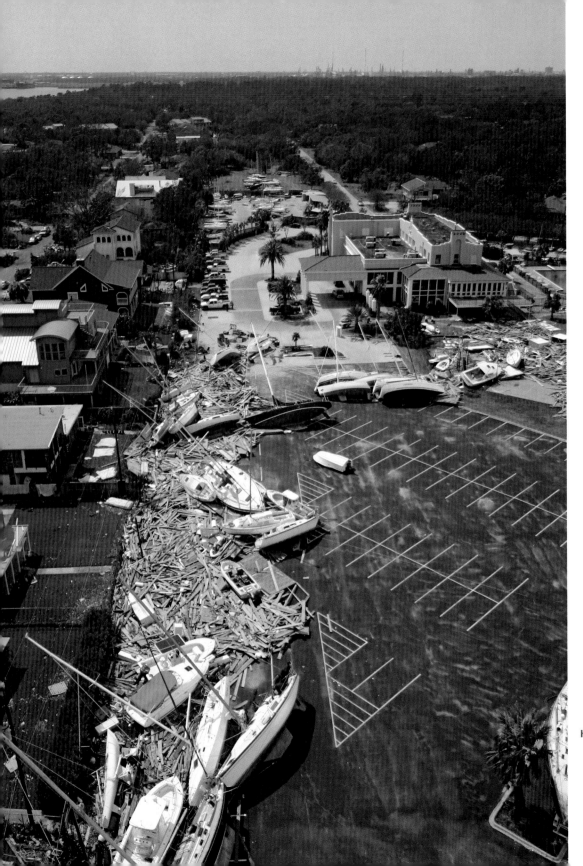

Houston Yacht Club.

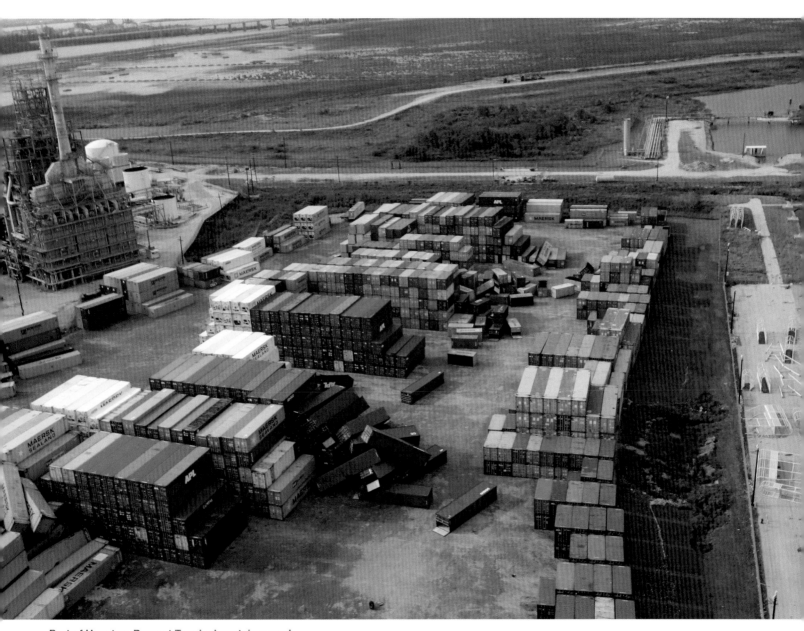

Port of Houston, Bayport Terminal container yard.

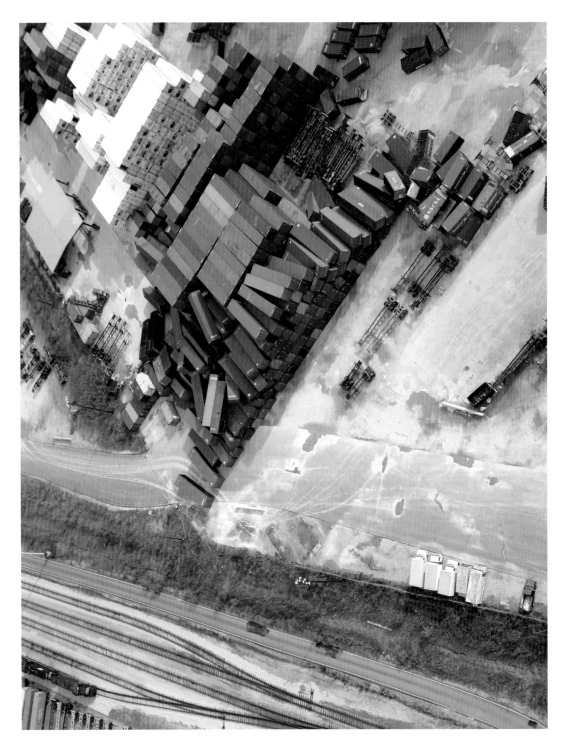

Port of Houston,
Bayport Terminal
container yard.

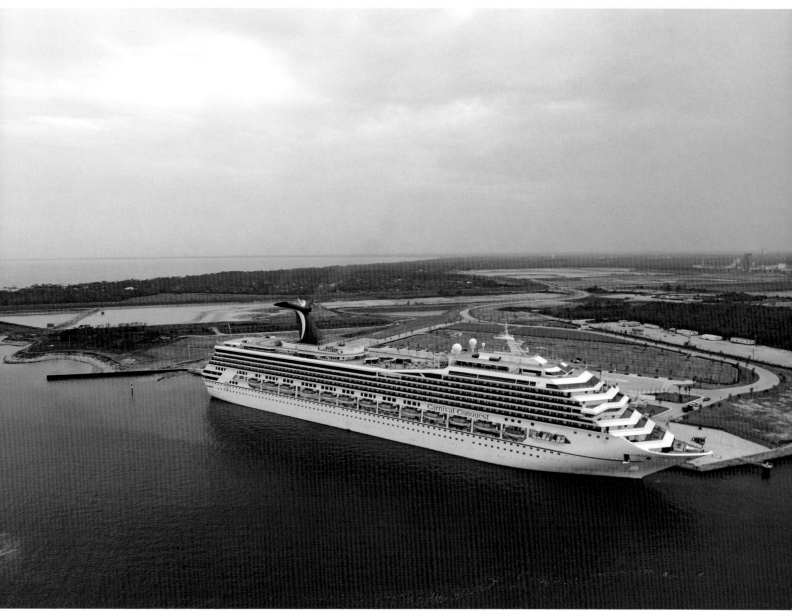

Port of Houston, Bayport Cruise Terminal and a Carnival Cruise ship relocated from its usual home port in Galveston.

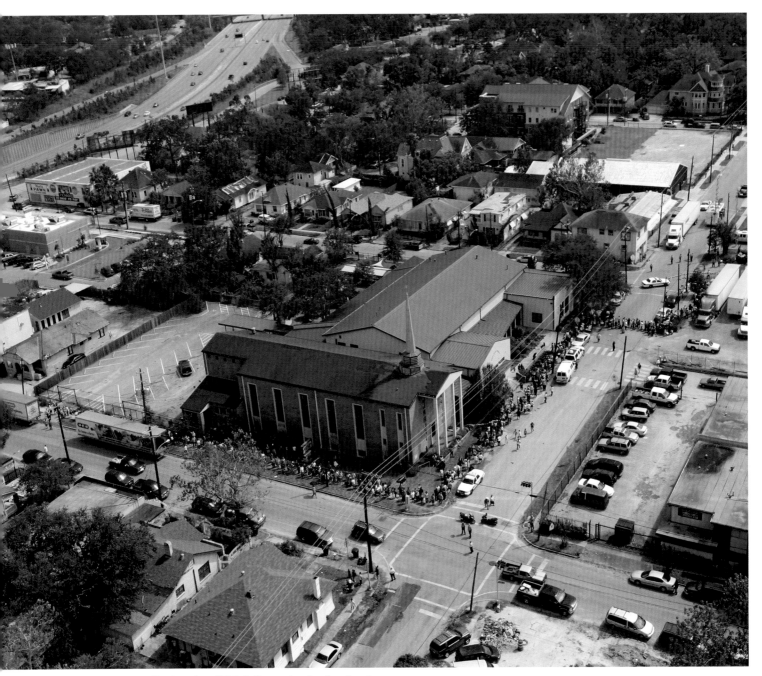

Point of distribution sites (PODs) dispensing food and water.

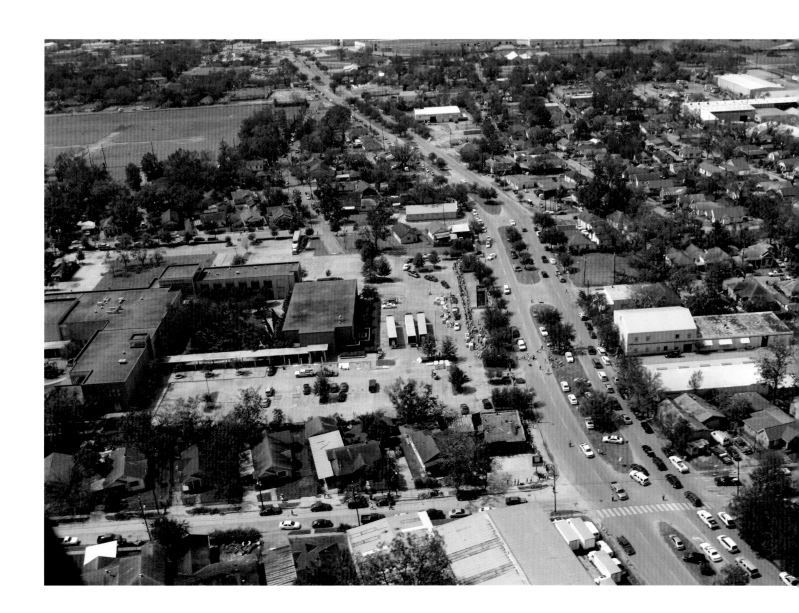

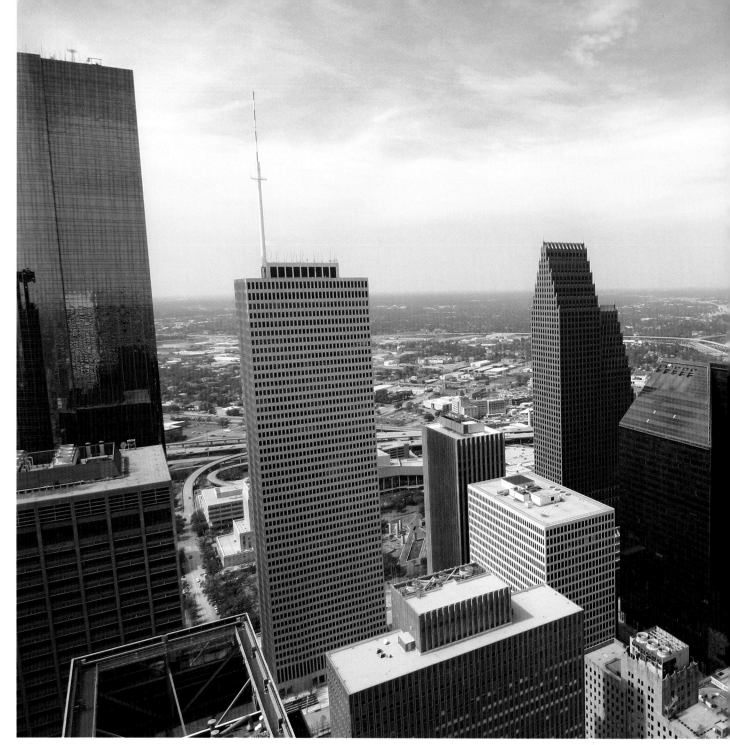

Downtown Houston. Glass from broken windows littered the streets below.

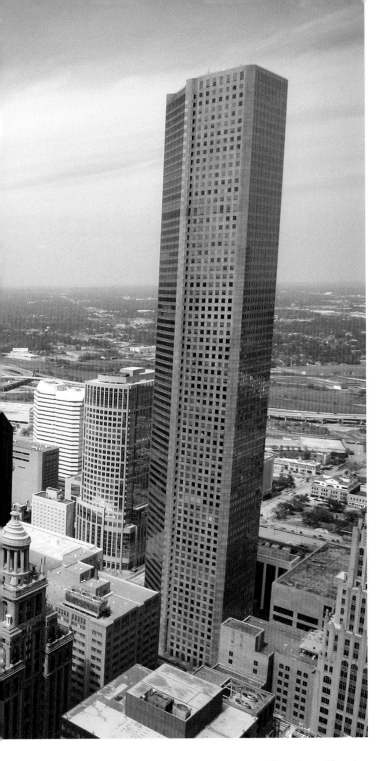

Downtown Houston.

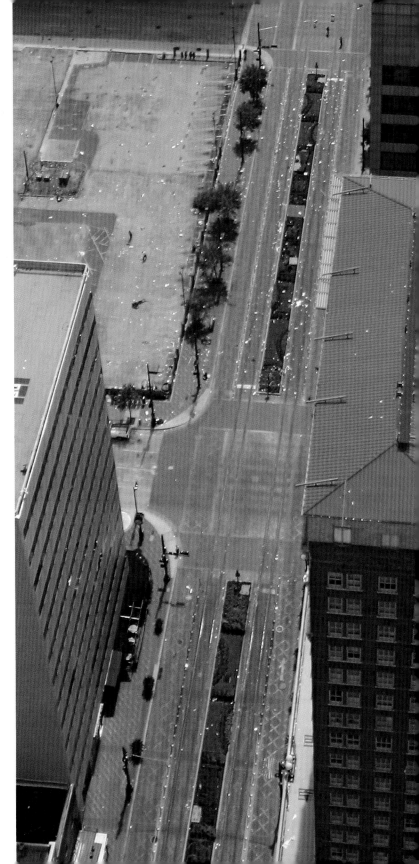

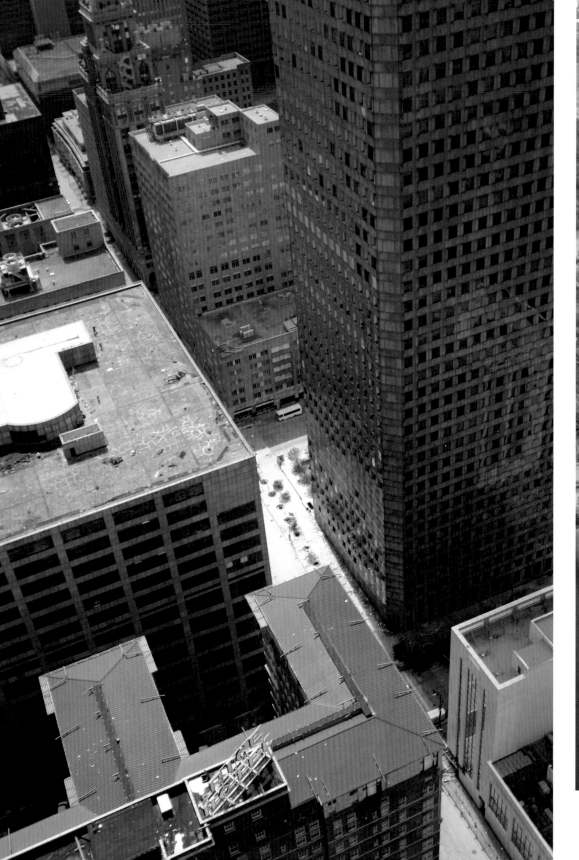
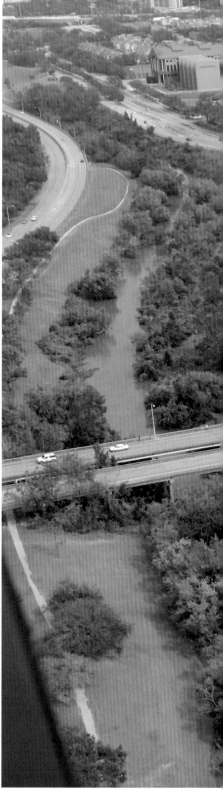

Intersection of Montrose Boulevard and Allen Parkway near Buffalo Bayou.

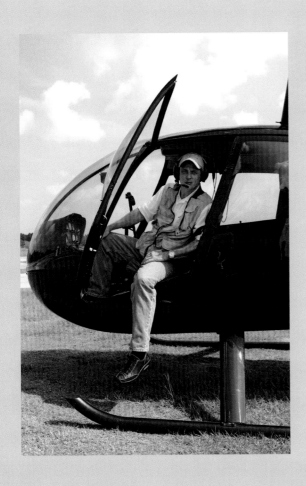

The digital photographs in *After Ike* were taken on either a Canon EOS 5D or a Canon EOS Rebel XSi with battery grips, using one of two lenses: a Canon EF 70-200 mm f2.8 image stabilized telephoto zoom and a Tokina AT-X Pro SD 12-24 mm wide-angle lens with UV filters. I used six 1-gigabyte CF memory cards and worked in Adobe Photoshop CS4.

In the air, I utilize a Kenyon Gyro Stabilizer and a Bose aviation headset with active noise reduction features. My favorite aerial photography platforms are a Robinson R44 helicopter and two fixed-wing aircraft: an American Champion Super Decathlon and a Piper Super Cub.

The maps were prepared at Beck Geodetrix using Geographic Information Science, utilizing Landsat 7 satellite imagery from the National Aeronautics and Space Administration and the U.S. Geological Survey, EROS Data Center, the national archive for remote sensing data of the earth's surface.

Gulf Coast Books

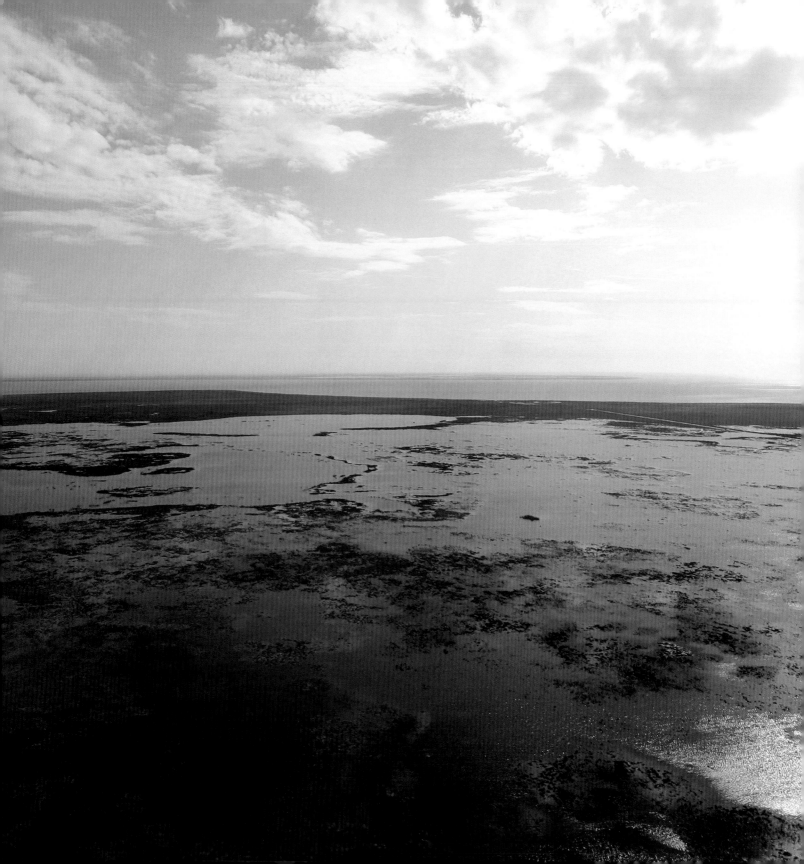